FIRST STEPS
SERIES

Drawing and Painting Animals

BILL TILTON

NORTH LIGHT BOOKS

Cincinnati, Ohio

About the Author

Author and illustrator Bill Tilton, former Disney and Columbia Studio artist in California, has an extensive art and academic background including studies at the University of Iowa under Grant Wood, Ringling School of Art, and an MFA from University of Denver. The recipient of many awards, his paintings are in some 450 private, corporate and government collections. He is the creator and long-time author and illustrator of the popular "Drawing Board" column for *The Artist's Magazine*. Bill and his wife Alice live comfortably in their Raleigh, North Carolina home where they are often visited by their five children and ten grandchildren.

Drawing and Painting Animals. Copyright © 1997 by William S. Tilton. Printed and bound in Hong Kong. All rights reserved. No part of this book may be reproduced in any form or by any electronic or mechanical means including information storage and retrieval systems without permission in writing from the publisher, except by a reviewer, who may quote brief passages in a review. Published by North Light Books, an imprint of F&W Publications, Inc., 1507 Dana Avenue, Cincinnati, Ohio 45207. (800) 289-0963. First edition.

Other fine North Light Books are available from your local bookstore, art supply store or direct from the publisher.

01 00 99 98 97 5 4 3 2 1

Library of Congress Cataloging-in-Publication Data

Tilton, Bill
 Drawing and painting animals / by Bill Tilton.
 p. cm.—(First steps series)
 Includes index.
 ISBN 0-89134-667-8
 1. Animals in art. 2. Art—Technique. I. Title. II. Series: First steps series (Cincinnati, Ohio)
N7660.T55 1996 96-19452
743'.6—dc20 CIP

Edited by Greg Albert and Jennifer Long
Cover and interior designed by Brian Roeth
Cover photography by Pamela Monfort Braun/Bronze Photography

North Light Books are available for sales promotions, premiums and fund-raising use. Special editions or book excerpts can also be created to specification. For details, contact the Special Sales Manager, F&W Publications, 1507 Dana Avenue, Cincinnati, Ohio 45207.

METRIC CONVERSION CHART		
TO CONVERT	**TO**	**MULTIPLY BY**
Inches	Centimeters	2.54
Centimeters	Inches	0.4
Feet	Centimeters	30.5
Centimeters	Feet	0.03
Yards	Meters	0.9
Meters	Yards	1.1
Sq. Inches	Sq. Centimeters	6.45
Sq. Centimeters	Sq. Inches	0.16
Sq. Feet	Sq. Meters	0.09
Sq. Meters	Sq. Feet	10.8
Sq. Yards	Sq. Meters	0.8
Sq. Meters	Sq. Yards	1.2
Pounds	Kilograms	0.45
Kilograms	Pounds	2.2
Ounces	Grams	28.4
Grams	Ounces	0.04

Dedication

To Senior Editor Greg Albert whose initial conception, enthusiasm and total support from beginning to end offered me the opportunity and freedom to do this book; to George W. Giles III, for his valuable technical word processing assistance and help with the preliminary layout of this book; to my readers, students, associates and personal friends; to my widely spread family; to James Michener, my most inspirational teacher of many years ago, who did his best to teach me how to express myself; and, above all, to my wife and best friend, Alice.

Acknowledgments

My special appreciation to friends Stephen Thomas of Support Services, and Kirk Taylor and Judy Wilburn of Askew Taylors here in Raleigh, North Carolina. All three friends of the arts have materially assisted me with this project, as well as with nonprofit art activities in which I have been involved. And my thanks to friends Nancy and Monty White for allowing me to use various of their menagerie for live models.

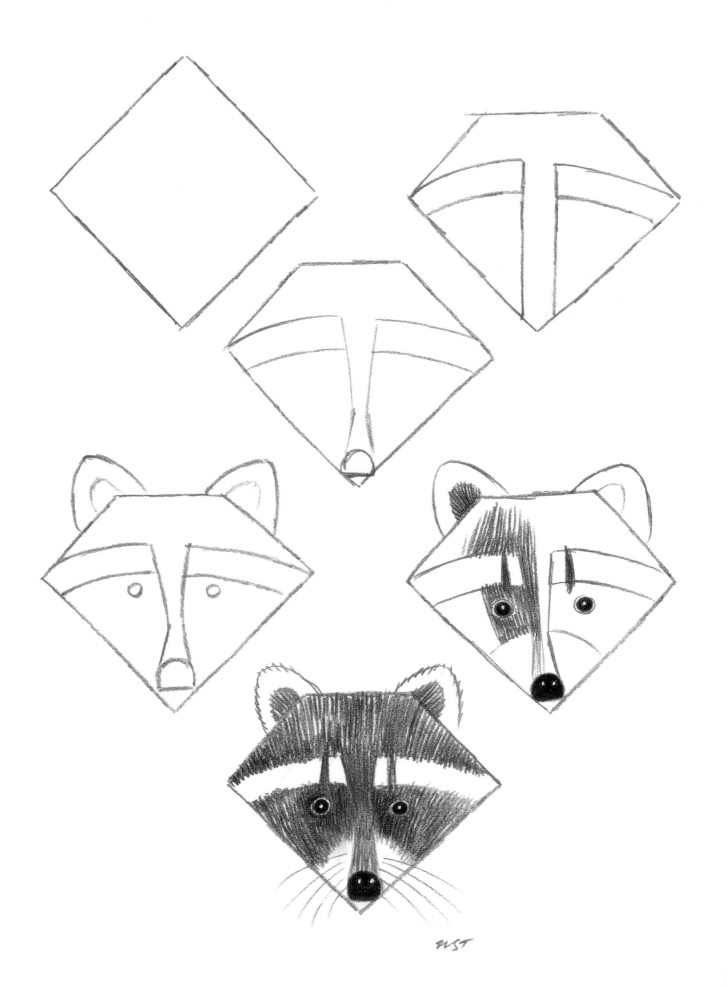

Table of Contents

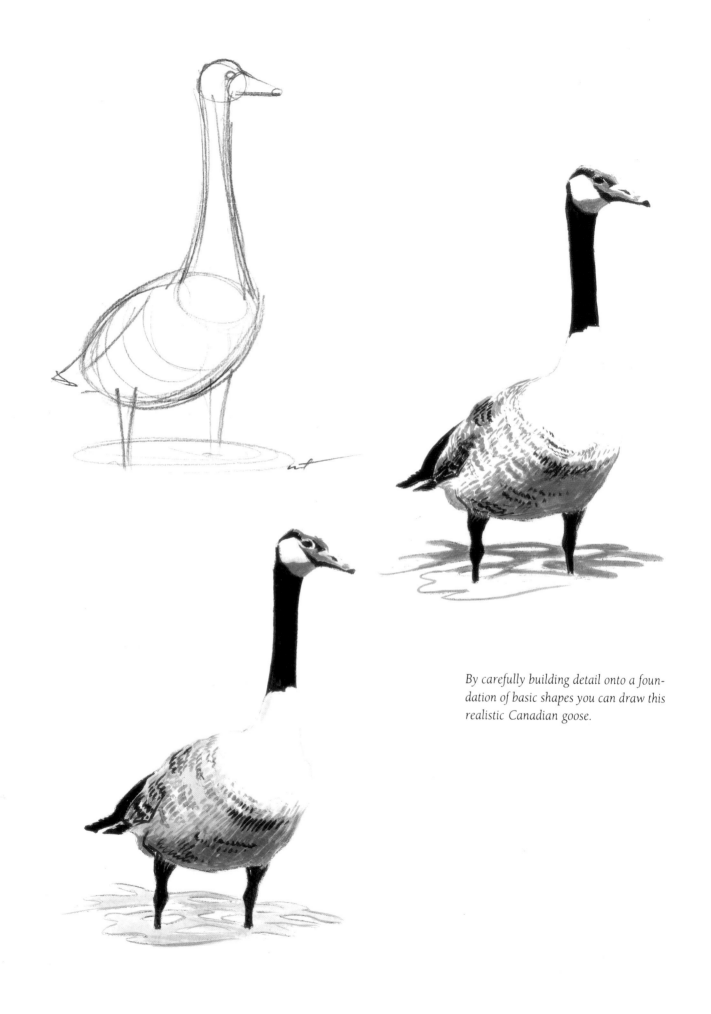

By carefully building detail onto a foundation of basic shapes you can draw this realistic Canadian goose.

Introduction

Ever want to draw and paint the animals that bark, meow, whinny, bleat and roar, but didn't think you could? I'll show you that you can!

My book provides guidance that is easy to follow and absorb, opening the door and windows for you on how to begin drawing and painting animals. Then it will take you further: You will discover as you page through the book, it is all much easier than you thought. Together we will cover a menagerie—from cats to elephants, chickadees to Canadian geese.

Thousands of individuals have told me they wished they could draw, but felt they lacked the talent. Just as many times, I showed them that within minutes they could draw recognizable objects. With reasonable patience and practice, I believe anyone who, like you, has enough interest to take some pointers and has the patience to practice, can learn the secrets of good, basic animal drawing and painting. And more!

An important word of advice is this: Don't get ahead of yourself and don't become impatient. Since you will essentially be your own teacher, ignore the well-meaning advice of those who may say you must never copy, never trace. On the contrary, I strongly encourage you to do so, and you are free to copy anything and everything in this book.

Famous artists have been copying admired works of others for centuries, but of course they never credit the copied work as theirs, nor should you. By copying and tracing work you find in my book you will not only enjoy the satisfying way a pencil fits in your hand as you draw, you will also gain lasting confidence that you too can make drawings that really look like the subject.

After you have completed this book you will have learned the solid basics for drawing animals. You will have a good start on painting them as well. This book's goals will have been met if you have enjoyed reading and copying it as much as I have enjoyed teaching the drawing techniques to you.

This simple exercise, in which you will exactly copy my drawings step by step, will give you the confidence you need to get started!

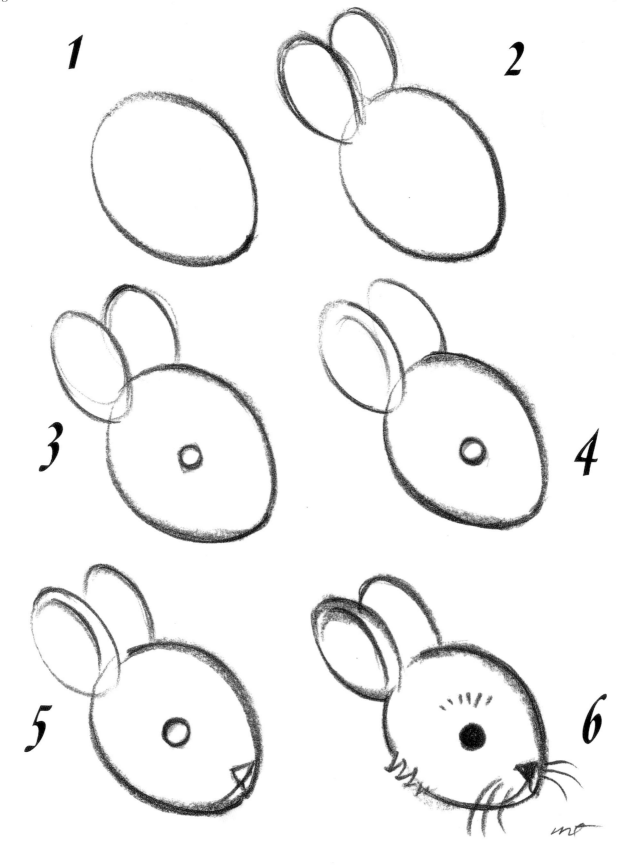

Chapter One

GETTING STARTED

The "get started" basics of drawing and painting animals are surprisingly simple. I believe this book will prove that to you. From personal experience, I know interested individuals can learn to draw. Of course, you must *want* to learn. The fact that you picked up this book clearly indicates you have an interest in drawing; so, with your interest and my belief, you can be taught to draw. We can't miss.

Warming-Up

Let's start with a simple, self-rewarding, do-it-yourself experiment. This is an easy, confidence-building "follow me" drawing exercise people have enjoyed at my workshops and demonstrations.

All you need is a piece of blank paper and a soft pencil—a no. 2 or softer works well.

The plan is this: You will copy my drawing, step by step, as exactly as you can. First, let me offer a few guidelines:

1. Look carefully at each step and follow every stroke you see. Good drawing begins with careful observation of the subject!

2. Copy each line as thick or as thin as you see it.

3. Draw each shape as exactly like mine as possible. If I draw a circle, make your circle a faithful copy of mine. If the next shape is an ellipse, do your best to make one of the same shape—and make its size compare faithfully to other shapes in the drawing.

4. There is no time limit and you are under no pressure; but, as a guideline, five minutes is usually ample.

5. When your drawing is finished, sign and date it; then, set it aside for several minutes. After that, *carefully* compare your drawing with the one in this book.

6. Put your drawing away in some secure place because we'll be coming back to it later.

Draw With Confidence

I am sure you did that easily, so sooner than you expect you will find yourself drawing more than you ever thought possible, and with ever-increasing confidence. I have found that using this method of careful observation and copying will build confidence. With confidence comes satisfaction, gratification and pleasure—all qualities that help make life truly worthwhile.

Having copied the simplified rabbit head, you are ready to progress further. As you did with the rabbit, you will be copying your way through this book, and, as you do,

you will feel your confidence increase and see significant, progressive improvement in your work. It is predictable that on completion of this book you will be able to stand on your own, producing original, good-quality drawings.

Learning how to draw and paint animals is the main purpose of this book, but the basics of drawing apply to every subject or object. These basics are so important to getting you started with sound drawing procedures that I will emphasize and repeat some parts over and over. Repetition is also an important part of learning

to draw and paint well.

Drawing and painting are great pleasures, even therapeutic, so I want the end result of my self-teaching examples to firm up your art enthusiasm. But please note: Don't search this book for theories, complex terminology or deep philosophical utterances about styles and art movements. Although those matters are important, my goal here is for you to experience the sheer enjoyment of drawing and painting animals. To get started, you will need a minimum of materials.

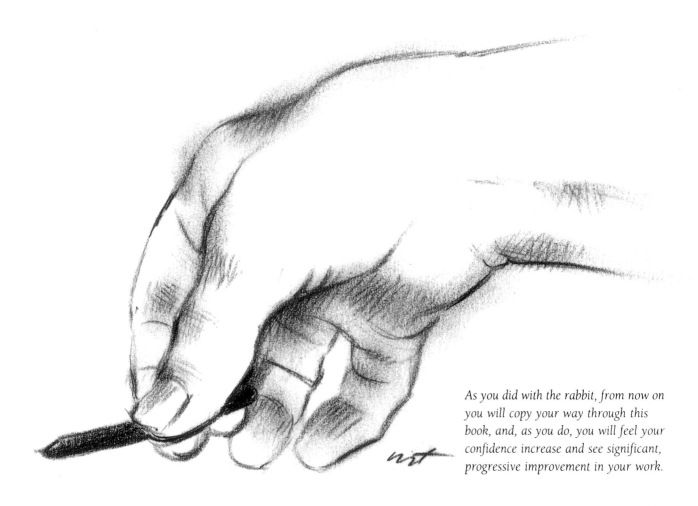

As you did with the rabbit, from now on you will copy your way through this book, and, as you do, you will feel your confidence increase and see significant, progressive improvement in your work.

Basic Materials

Professional artists acquire a sizeable collection of art materials suitable for almost any project. Are they all necessary? By no means. Does a beginner need a host of art materials, and expensive ones at that? Of course not! You can learn to draw and paint with a few select, affordable items. As a broad guideline, my dictum is this:

> *"For the short term, practice inexpensively; and for the long term, draw and paint expensively."*

That is, use the highest quality materials you can find and afford for final work. Getting started does not require that you spend lots of money on beginning materials. Anyone on a tight budget should be comforted to know it is quite certain even the least expensive art items you can buy are better than those available to renowned artists many centuries ago.

The essentials for doing art include good lighting (to minimize eye strain and assure colors are rendered accurately), something comfortable to sit on, and some sort of drawing surface (like a lightweight, hollow core drawing board you can hold in your lap, resting the other edge on a table).

Paper and Pencils

To follow this book's step-by-step procedures, I recommend you use standard copy paper and reliable pencils. My preferred pencils are made by General Pencil Company. They include: (1) General's no. 588 sketch and wash pencil that features soft, water-soluble clay and graphite "lead" (correctly called inner core because of its balance); (2) General's layout pencil, no. 555; (3) General's sketching pencils no. 533-4B and 533-6B; and (4) General's charcoal pencils. I particularly like two other products, although both seem hard to come by. First, because of its balance,

I favor the Cross 9mm mechanical pencil that holds soft (2B) lead. Second, when I can get them, I always try to have assorted grades of carbon pencils by Wolfe's of England. Unless noted otherwise, the black-and-white illustrations in this book are drawn with the pencils mentioned in this paragraph.

You can find good copy paper at most "quick copy" places and at office supply and stationery stores. I get a good-quality paper suitable for business correspondence. My favorite copy papers will accept any pencils, pens, brushes and ink, and any pastels. Note, however, that *I do not use* these papers for anything I expect to be permanent.

Copy paper, although not archival, will do well for your practice work and most of your self-teaching lessons. As you inevitably improve, you will probably want to use better-quality paper of the kind stocked by reputable art supply stores. The appendix contains information about other papers, canvas, hardboard, etc., which you will want to try as you progress in your art skills.

Erasers

Above all, select an eraser that cleanly erases rather than smears. For most erasing I use and recommend the Factis ES 20, which I cut into various shapes (for use in smaller spaces) and, of course, traditional kneaded rubber erasers.

Fixatives

I lightly use a dependable fixative to keep what I have drawn from smearing. Available at art stores, any of the spray cans of quick-drying workable fixatives will do nicely. Fixatives let you add additional layers and other mediums without disturbing the work underneath. Light spraying is

always best. As a good health practice, spray fixative outdoors whenever possible, or use it with a good ventilation system. In any event, carefully read the health safety information about usage and contents.

Brushes

Kolinsky sables are the best, but I use synthetics for most of my work. Get a no. 5 or no. 6 round brush that comes to a fine point. Also get a ¼-inch flat watercolor brush. As you become more proficient you will want other brushes, but most are expensive and, sadly, it's a fact that quality and cost go hand in hand.

Watercolor

If you have never used this medium, buy yourself an inexpensive set of twelve to twenty-four pan colors. A regular plate or saucer serves as a good palette.

Quick Start Shopping List

Here's a list of the basic materials you'll need to get off and running. Take it to your local art supply store where the clerk can help you gather these essentials:

4B graphite pencil
6B graphite pencil
carpenter's flat sketching pencil
sketch and wash pencil with soft, water-soluble graphite
charcoal pencil
package of inexpensive copy paper
white, plastic eraser
kneaded rubber eraser
can of spray fixative
no. 5 or no. 6 round, synthetic brush with a fine point
¼-inch flat watercolor brush
starter set of twelve to twenty-four pan watercolors

My Favorite Pencils

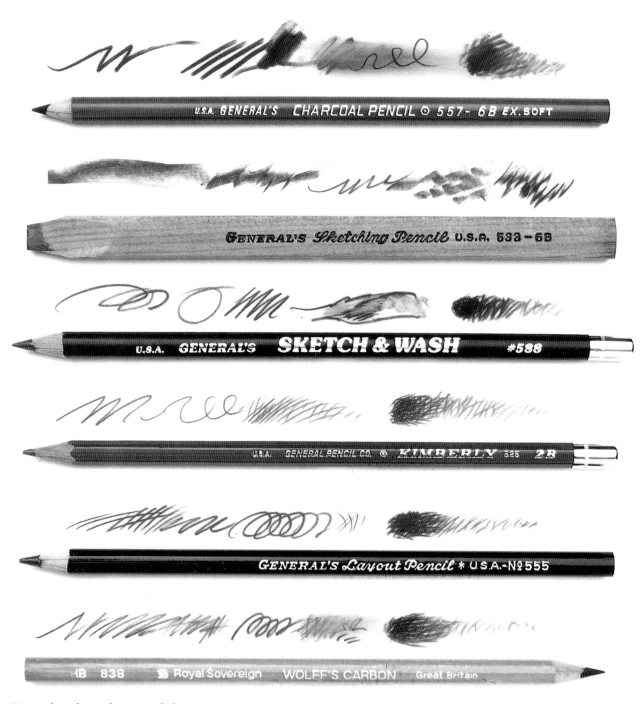

My preferred pencils are made by
General Pencil Company. Shown here is
a basic assortment with the variety of
marks each will produce.

Additional Supplies

Your desire to try some other art media will increase as you progress in your drawing and painting. You can count on it! In the appendix I have listed reliable sources for a host of fine, specialized books, art material catalogs and VCR art instruction tapes related to the media discussed in this book. At the least, you will want to try *some* of the media mentioned. As a convenience, let me briefly describe and comment about other popular media I believe you will want to try as your drawing skills improve.

Sketchbook

A sketchbook is always useful for making on-the-spot drawings and timely notes when traveling or visiting a zoo, farm, ranch, etc. My preference is a sketchbook with good paper and a spiral binding that allows the pages to lie flat. When on the go, I also bring a few watercolor pencils of frequently used colors, a small brush and a miniature watercolor box with a self-enclosed palette and mixing tray. A baby's nursing bottle—the kind with a leak-proof, plastic, screw-on cap—is fine for carrying water. I often add a fine waterproof ballpoint pen, my personal favorites are Faber-Castell's Deluxe Uni-Ball model and Sakura's line of Pigma Micron waterproof pens.

Charcoal

Charcoal comes in various thicknesses and degrees of softness and hardness, and it smudges or blends easily. In skilled hands, charcoal can produce superb, museum-quality drawings.

General's white charcoal pencil (and/or any white pastel pencil) combined with vine charcoal and a carbon or a charcoal pencil produces impressive three-dimensional drawings.

Pastel

A popular, dry, chalklike medium offered in stick and pencil forms, pastel comes in a variety of sizes, an amazing range of colors and varying degrees of softness or hardness. It can be used on an extensive range of papers and specially treated boards that have "tooth" (as opposed to slick, smooth paper surfaces). For sketching, pastel also works well on quality typing and copy paper.

Pen or Brush With Ink

Another popular, centuries-old method for making easy-to-reproduce black-and-white drawings, as well as an extensive range of two, three or more color works. Many papers and illustration boards are suitable for this medium. A wide range of pen points are available and most brushes are suitable.

Water Media

A term applicable to a number of highly favored painting methods involving types of color media that use water for thinning and application. Traditional, transparent watercolor and acrylic paints enjoy worldwide popularity as, to a lesser extent, do gouache (opaque watercolor) and casein. An extensive range of painting surfaces, from rough to smooth, can be used for these media.

Many of the illustrations in this book were done with water media. Where pertinent, I've mentioned procedural methods and a number of tips, as well as brands I like.

Oil Paint

The traditional medium for fine art painting of all kinds, oil masterpieces are found in every noteworthy museum around the world. Oil paint is

When pressed onto your drawing, kneaded erasers can lighten darks and lift out white highlights. Plastic erasers are handy for cleanly eliminating mistakes.

used on a wide assortment of primed surfaces, from stretched canvas and linen to durable, inflexible surfaces like untempered Masonite. An impressive number of oil paints and individual mediums is available, each imparting its own qualities to a painting. Equally as many oil painting methods exist: smooth without visible strokes, alla prima (all at once) and painting with a knife, to name a few. Each method has its own strong advocates.

When doing illustrations, I often use oil paint thinned with mineral spirits on various types of papers. This is a quick, easy, fast-drying painting method. For permanency with this technique, use only archival papers, preferably with at least one coat of gesso.

Another excellent working method combines both oil and acrylic paints. Here's how I do it: Beginning with a gessoed surface (canvas, untempered Masonite, prepared pressure board and the like), I do a reasonably complete painting with thinned acrylics. When that paint is dry, I use it as a guide to paint over the acrylic with oil paint. I apply many thin coats of oil paint, allowing each to dry before applying another.

Putting It All Together

My challenge in writing this section is to tell you what I believe you need to know about the basics of drawing animals. I enjoy drawing animals and want you to learn and enjoy it as well, so rather than just walk you through the process with words, interspersed throughout the text are dozens of drawings you should copy step by step. To repeat, throughout the book I actually want you to copy each shape and drawing as precisely as you can so you get the feel of actual drawing imbedded in your subconscious.

Most of my grandchildren enjoy drawing, so each visit with them involves a few art lessons. One grandson, with definite art potential, found some of my follow-me drawings difficult until I realized he is left-handed. Learning that, I have included on the next page an application illustration showing what I think is the most ef-

fective way to hold a pencil whether left- or right-handed. At bottom left is a sketch of a contemporary pencil-holding method that makes drawing difficult, if not almost impossible. I dislike being negative, but try hard *not* to hold a pencil like this. The sketch to its right shows the time-proven way to draw and be able to see what you're drawing, varying how close to the tip you hold your pencil to suit your personal taste.

Beginning artists often have an understandable tendency to record surface detail too early, and the result is frustrating and demoralizing. For now I want you to learn some simple methods that will make drawing the foundation of your subject easy: an absolutely necessary step before you concentrate on detail.

For best results, avoid using heavy pencil pressure because it scribes

deep grooves in your paper and often tears through it. Use pencil pressure only to make an emphatic stroke, show weight or add impact to your line. When possible, unless intentional, avoid small, tenuous, unsure strokes that often indicate lack of confidence. Small strokes also tend to be used in a vain attempt at recording an elusive profile of something. Bolder strokes, which sense and delineate mass, are clearly better.

Incidentally, with any of the General pencils I recommend a simple trick to get a jet black mark. Simply dip the point in mineral spirits or lighter fluid and stroke the point on your paper. Both these liquids are solvents for graphite—which is the stuff in your pencil erroneously called lead!

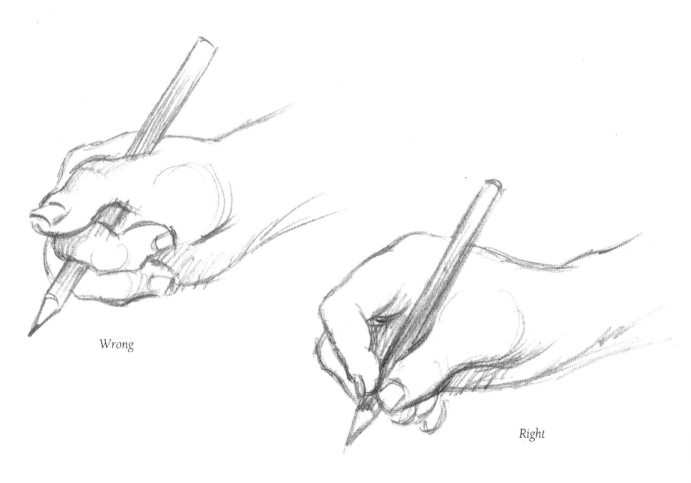

Wrong

Right

The Carpenter's Pencil

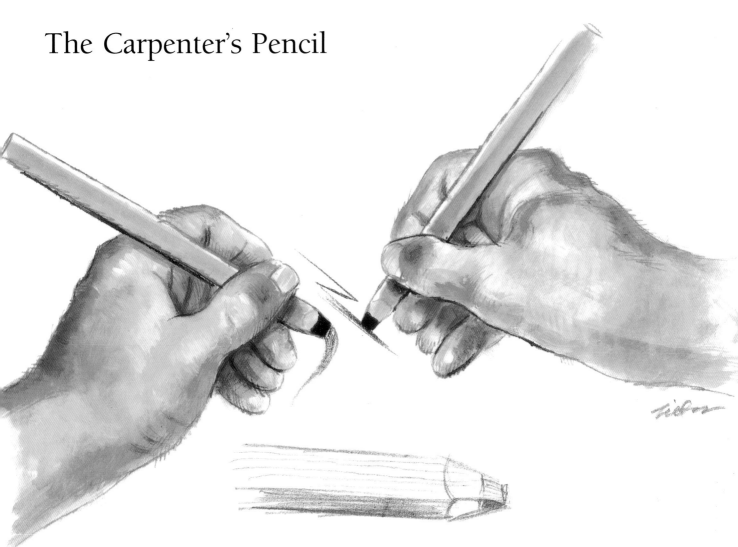

Begin with the rightfully renowned sketching pencil (the so-called carpenter's pencil). Working with this kind of pencil denies the less experienced from getting caught up in unmanageable detail. Hold it one way and you'll produce flat lines, hold it another way and you'll get an easily controlled, thin, vertical line.

To get the best use from this pencil it must be sharpened properly. To do this I use either a sharp matt knife, a good single-edge razor blade or a sharp pocketknife. Above all, be careful. These cutting instruments can inflict some real damage when used improperly. The above illustrations show how your pencil should look. After sharpening, play around with it a bit to get a feel for what it can do.

With a little practice doing various strokes you'll quickly find this pencil easy to use, especially for doing straightforward shapes that are the essence of good drawing. You will learn easily how to vary the pressure and get strokes as light or dark as you wish. The wide lead lets you define forms as well as shadow, and helps you literally feel their mass as you draw. In contrast, you'll discover how the thin side lets you define hard edges close to the surface or in the light. In essence, this pencil is a superb drawing tool, and you're bound to like it. 4B and 6B pencils are recommended.

The Four Basic Shapes

You must start with a clear understanding of what is involved in the making of a drawing in general. It is centuries-old knowledge that virtually every object or subject can be represented when the drawing or painting is based on four common forms and variations—and the combinations of them. These forms are: (1) a circle (or sphere); (2) a square (or cube); (3) a rectangle (either a brick or columnar shape); and (4) a triangle (seen as a pyramid or cone).

The four basic shapes illustrated in the following pages are, with variations, the actual or implied foundations of any realistic painting, drawing or sculpture ever created. If you look at it this way, drawing is simple; just draw the right shapes in the right sizes.

Your secret for drawing every animal in this book is your ability to see the four basic shapes, plus the fifth (the peanut) I've added, and to be able to draw them adequately. Copy each of the following pages. Later, continuing to use these shapes on your own, you will see for yourself that you can draw everything you see or imagine, anywhere and anytime. I continue to practice drawing these shapes daily, moving them around in space in every conceivable variation. They are as familiar as my own signature.

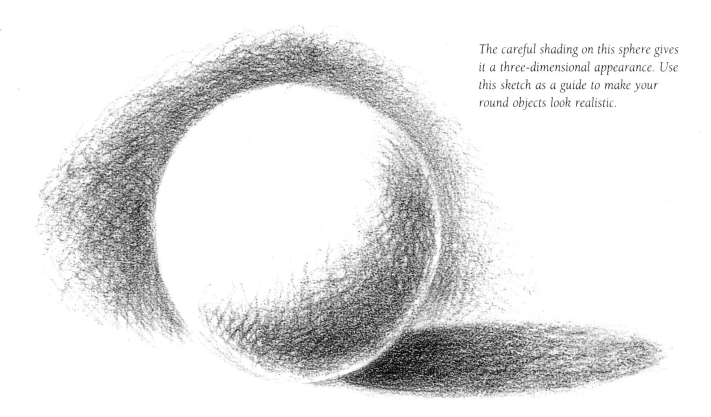

The careful shading on this sphere gives it a three-dimensional appearance. Use this sketch as a guide to make your round objects look realistic.

Circles

When you're drawing a ball or sphere, even though you're drawing on flat paper, imagine your lines going behind and around the form. You should get the feeling the line is lighter as it goes away from you, lighter on the top or area in the light, and heaviest on the bottom. Keep at it. Before long you will know when it "feels right."

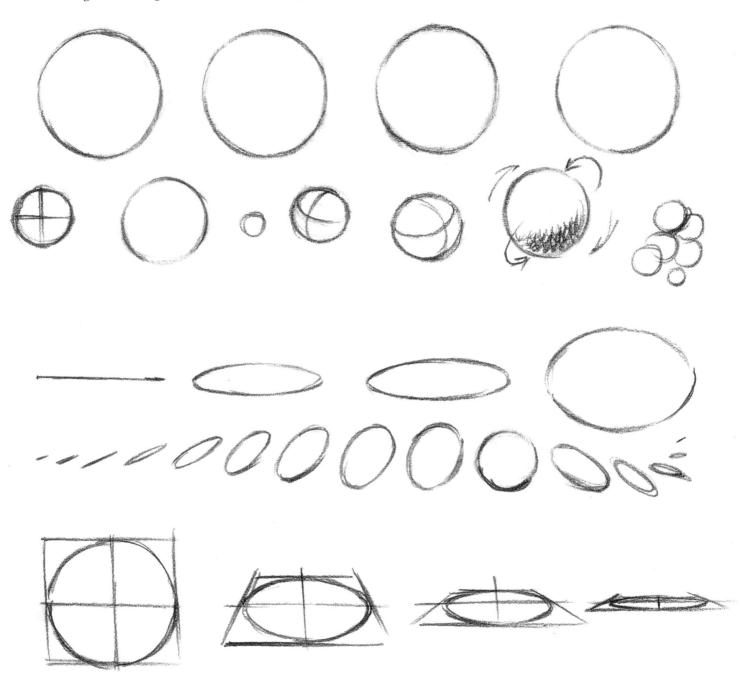

Squares and Rectangles

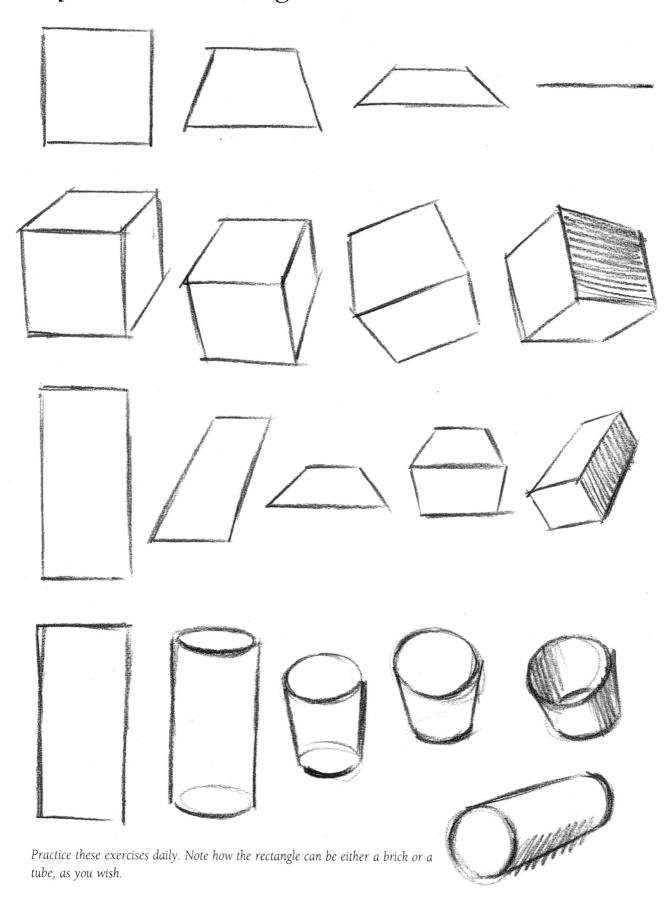

Practice these exercises daily. Note how the rectangle can be either a brick or a tube, as you wish.

18

Triangles

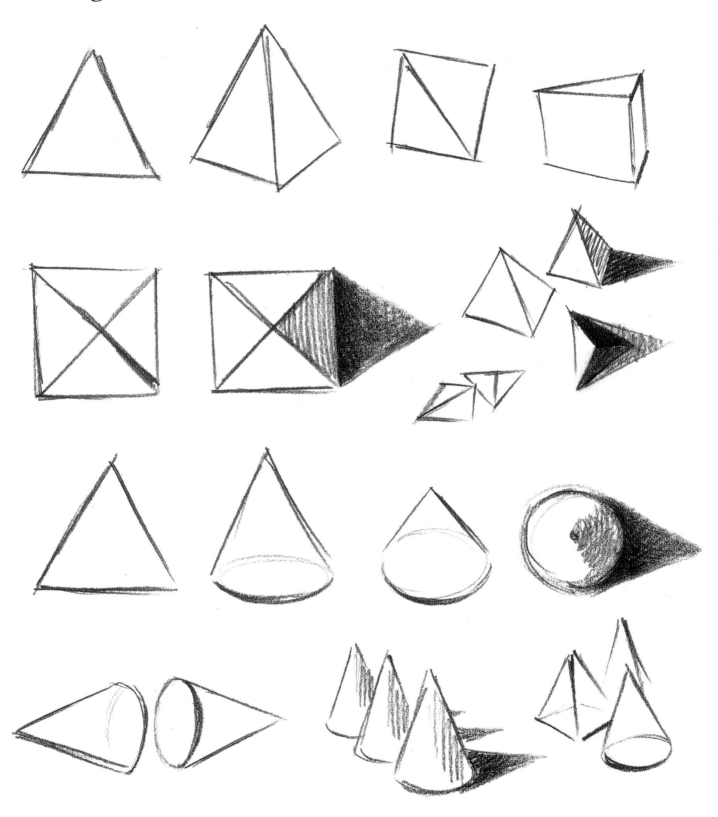

Practice these triangles, converting them into both pyramids and cones.

The Fifth Shape

To the four basic shapes I add a fifth, a form I use extensively, which I call the peanut (or, you may prefer, potato), which is simply a combination of two circles (spheres). It is the most useful shape I know of for beginning any animal or bird drawing. I use it in the majority of my drawings and paintings. With some practice, I am confident you too will find it equally helpful.

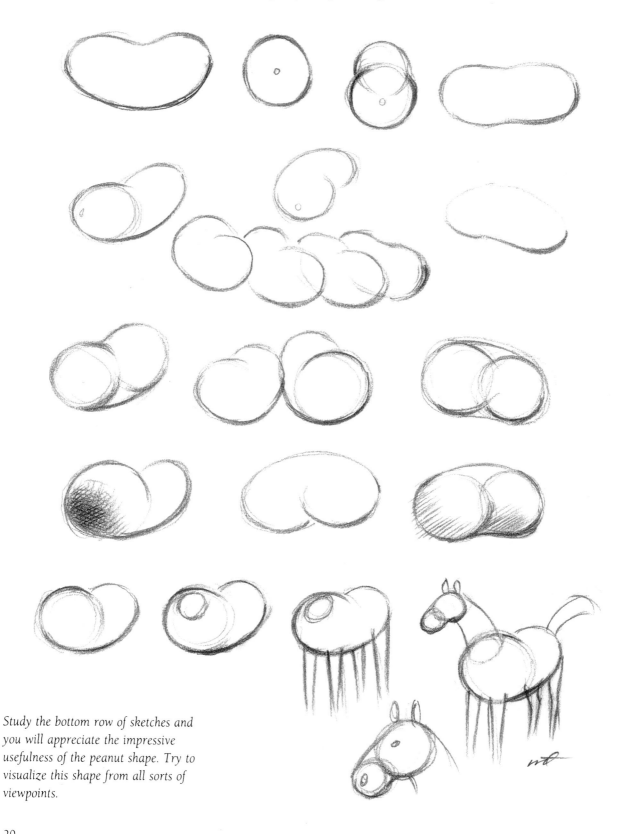

Study the bottom row of sketches and you will appreciate the impressive usefulness of the peanut shape. Try to visualize this shape from all sorts of viewpoints.

20

Practice, Practice

As you practice the four basic and peanut shapes, learn to turn these flat symbols into three-dimensional forms. With a little imagination you can see how these familiar objects can be "visualized" in relation to the shapes of different animals. For now, consider varied bottle shapes and try to see in them familiar animal bodies—a pet bird or cat, for instance.

Eventually you will take a giant step forward and automatically begin to picture shapes of objects in relation to specific animals. You will be doing the same thing most of us did as children: seeing faces and objects in changing shapes and masses of cloud formations, but now you will relate to more earthbound objects.

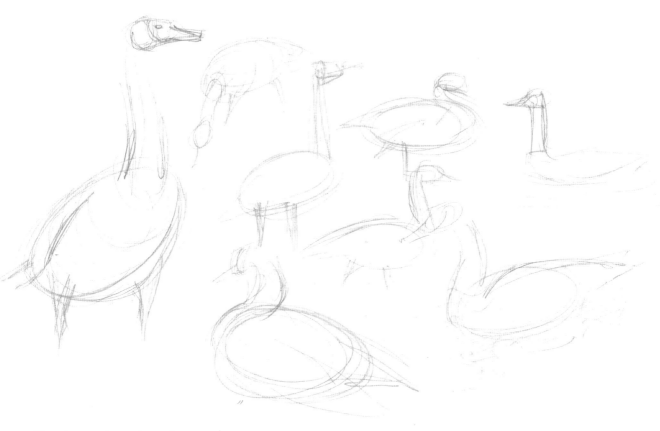

Here is a good exercise to do even when away from your paper and pencils: Look at objects, especially animals, around you and mentally break them into basic shapes.

Gestures

When sketching, the first important step is to draw the basic overall shape of your selected animal subject with the fewest strokes needed to identify what you are drawing. These are called gestural sketches, i.e., the essence of a movement. These two pages show a typical collection of such gestural sketches. They could be drawn even simpler and still enable you to identify the subject. Gestures are quite similar to caricatures, since, if the latter are to be successful, they must contain the essence of what makes one person look different from others.

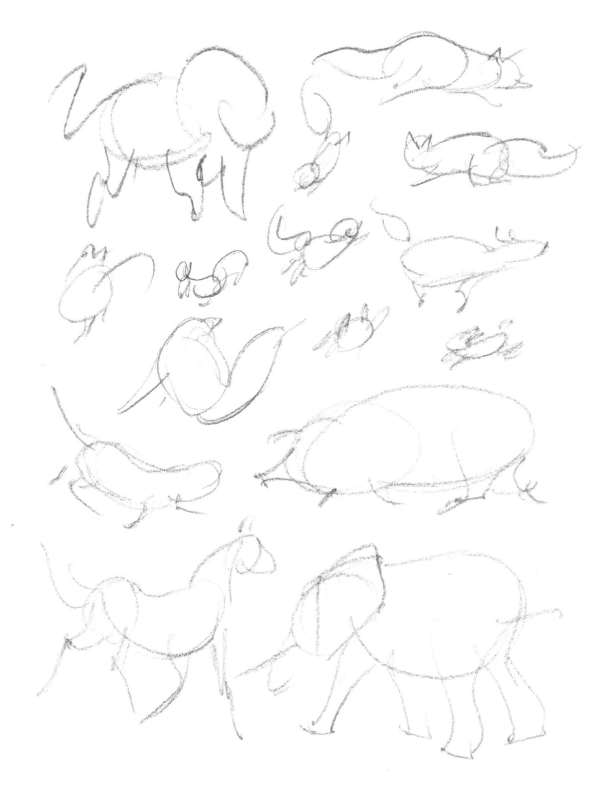

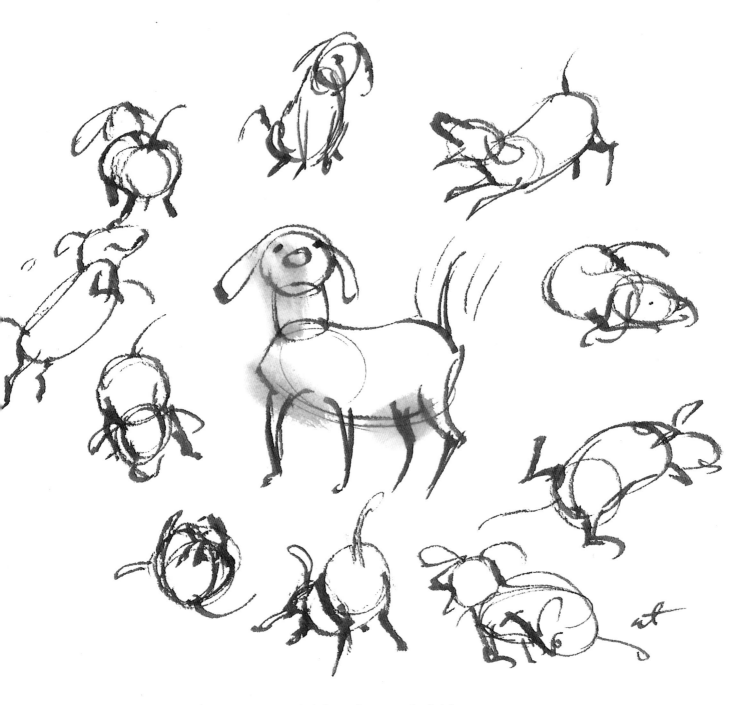

Re-create the previous page of gestures using quick, light strokes to get the feel for this type of action-sketching, but don't worry about making exact copies. Try to complete all the sketches in under two minutes. Then try some gesture sketches of your own using a family pet, or nearby squirrel or bird, as your model.

Refined Gestures

In the drawings you will be doing, begin with a shape or shapes that suggest your subject, then add lesser but significant shapes and a few details.

When that rough, overall shape looks convincing, start building on that shape, bit by bit, refining your drawing to the extent you wish. Then step or lean back and look at your effort. Continue to refine and you will eventually have a satisfying representation of the animal of your choice.

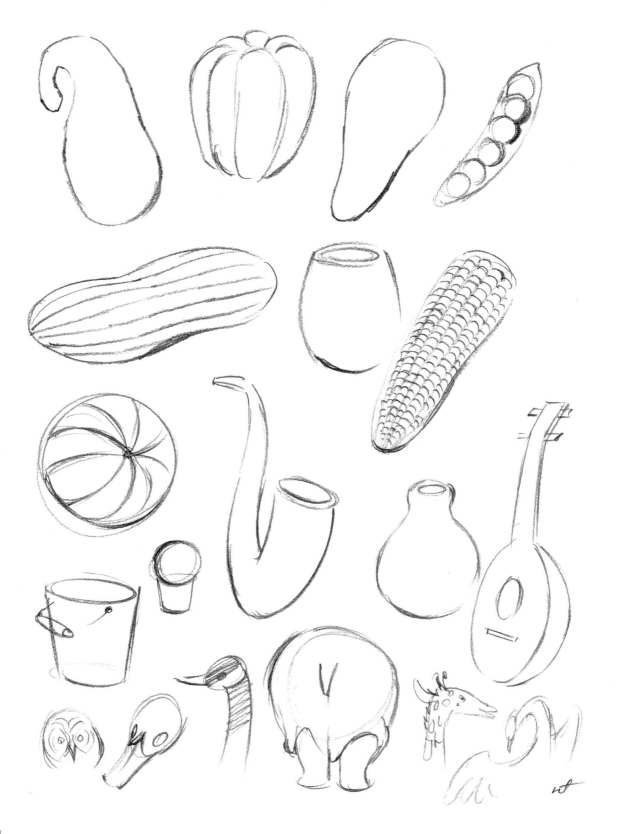

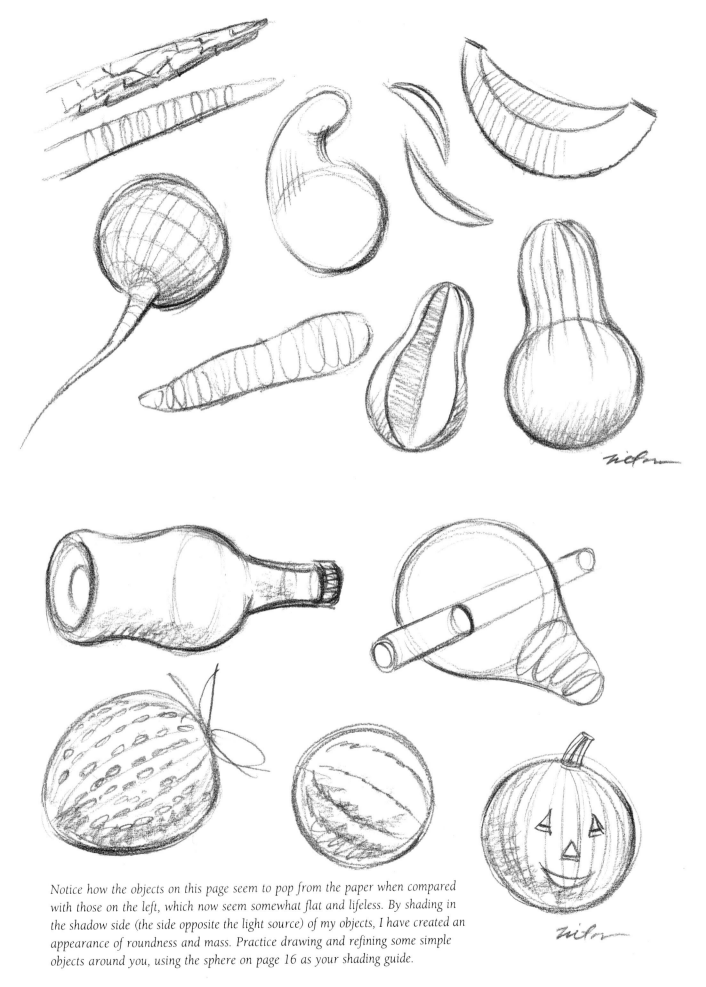

Notice how the objects on this page seem to pop from the paper when compared with those on the left, which now seem somewhat flat and lifeless. By shading in the shadow side (the side opposite the light source) of my objects, I have created an appearance of roundness and mass. Practice drawing and refining some simple objects around you, using the sphere on page 16 as your shading guide.

Drawing Mass

Mass, simply stated for our purposes, is the amount of space taken up by an object. When you look at an actual can or apple, you are not seeing just an outline because you are not looking at a cardboard cutout or a silhouette. You are looking at an object you can wrap your fingers and hands around. You are looking at *the mass* of that object, that can or apple. The ability to draw mass convincingly is important to artists who want what they draw to look like the subject being drawn.

If you have a pig or other animal handy, like Nancy White's Hampton shown on these pages, you have a full-time drawing and painting course wrapped up in one. Drawing and painting a single animal, if that is the only model available, can be an invaluable teacher. The more you draw the whole, and then the bits and pieces, from every angle and in every lighting condition, the better you will become. And what better way to start than copying both pages of these pig drawings.

PIG FOUNDATION

The peanut and circle shapes make up the basis for this pig sketch. Look how the heavy lines immediately give an impression of the pig's mass and weight!

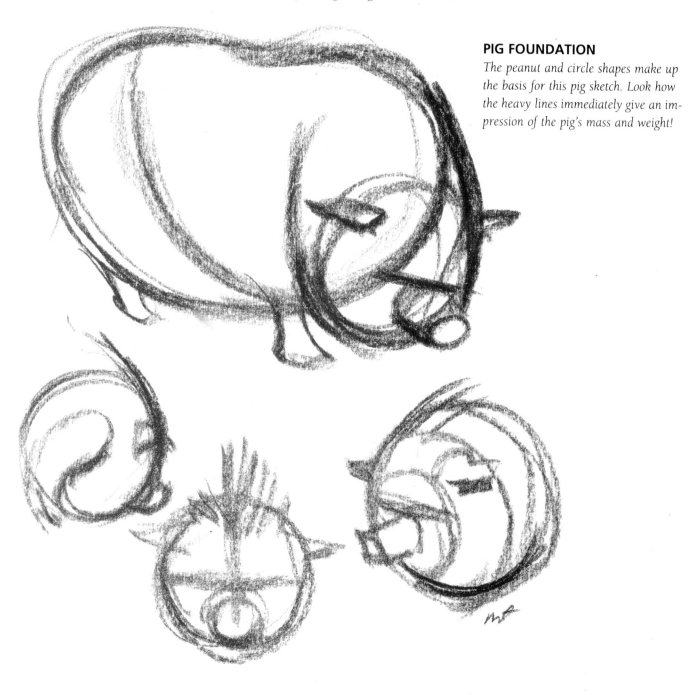

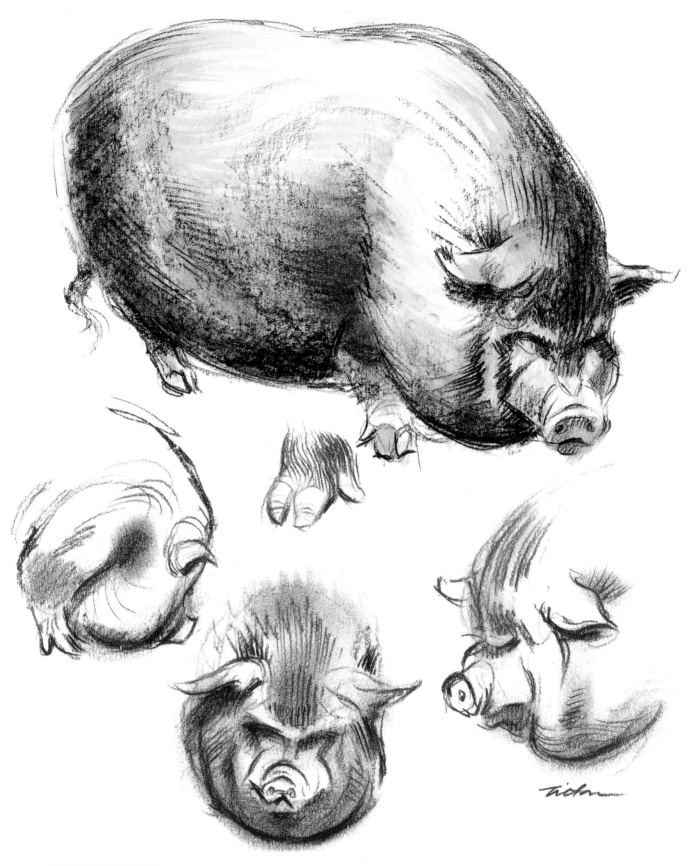

REFINING THE PIG

Carefully observe how the dark shading on the underside and rear of this pig, contrasted with the highlights on its back and right shoulder, show us exactly how the light source wrapped around the subject, making it apparent the subject has mass. Can't you almost feel the weight of this pig?

Draw a Cat

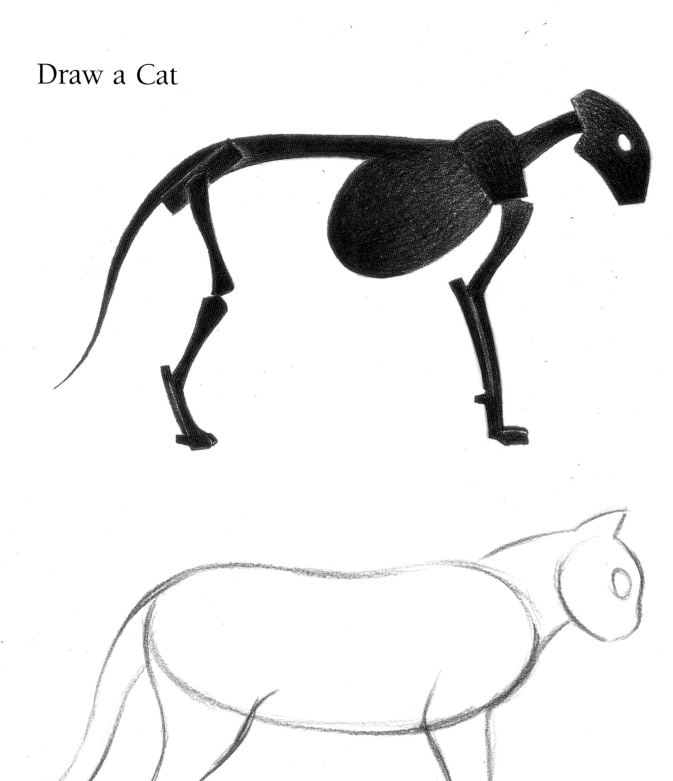

CAT FOUNDATION

The drawings in this next exercise are offered to give an easy example of drawing a cat as it contrasts with the pig previously shown. Take your time and copy all the cats shown in the following drawings.

28

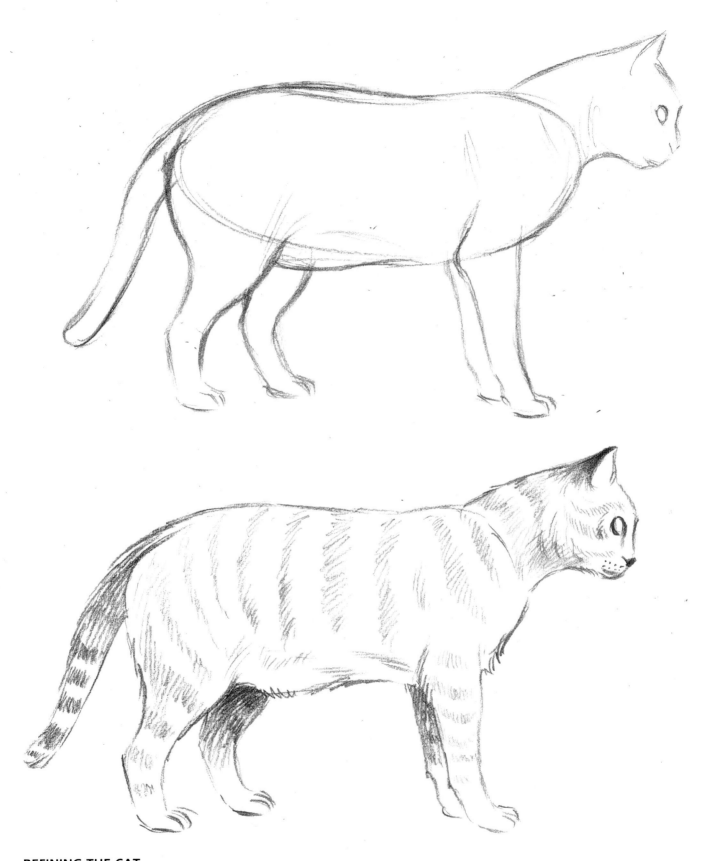

REFINING THE CAT

After erasing unwanted lines, begin to add stripes with a pattern of careful, short strokes. Notice how the angle of the stripes follows the lay of the fur and the curves of the cat's body, suggesting mass.

Draw a Cat in Charcoal

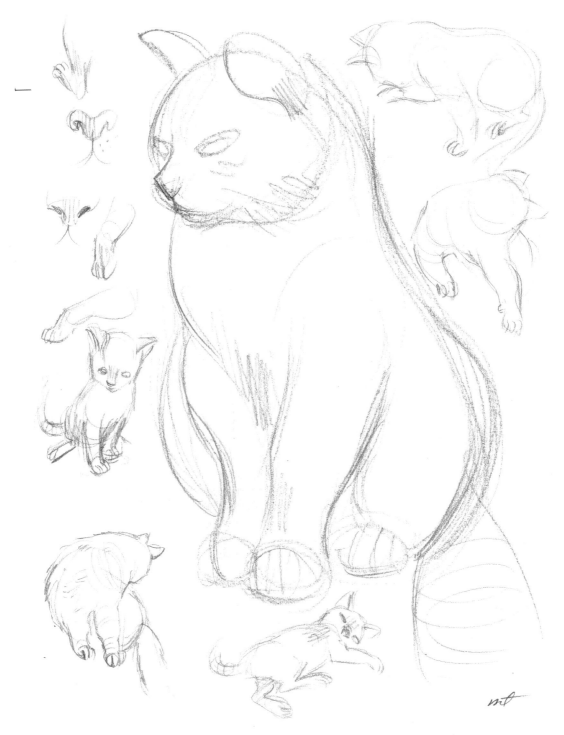

At this early stage it may surprise you to learn I believe you can successfully copy this large charcoal drawing of a cat. I am confident you can and here's why. The drawing is made entirely of a series of soft strokes with a General 6B charcoal pencil. I simply rubbed the strokes together to make them look smooth, adding more strokes when I wanted an area or details darker. When satisfied, I sprayed fixative on the sketch and let it dry. Finally, I added some strokes of white acrylic for whiskers and some body hairs crossing dark areas. Try this and be amazed!

CAT FOUNDATION

Here are some quick gestures of a cat and kitten. Copy the large foundation sketch for your charcoal drawing.

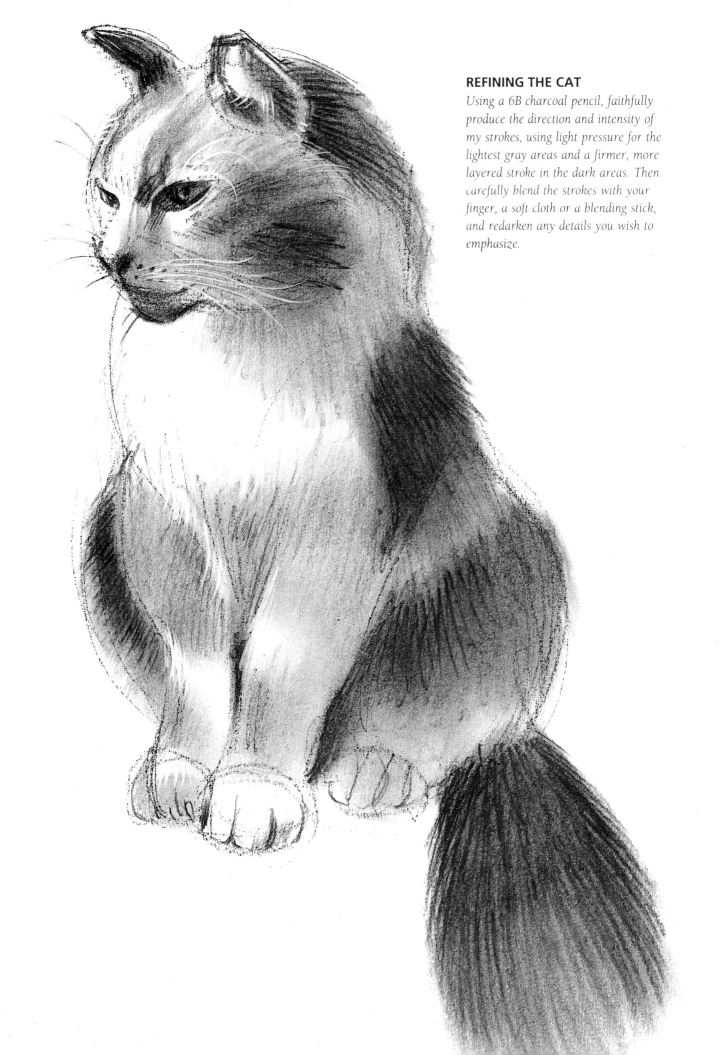

REFINING THE CAT

Using a 6B charcoal pencil, faithfully produce the direction and intensity of my strokes, using light pressure for the lightest gray areas and a firmer, more layered stroke in the dark areas. Then carefully blend the strokes with your finger, a soft cloth or a blending stick, and redarken any details you wish to emphasize.

Draw a Pelican

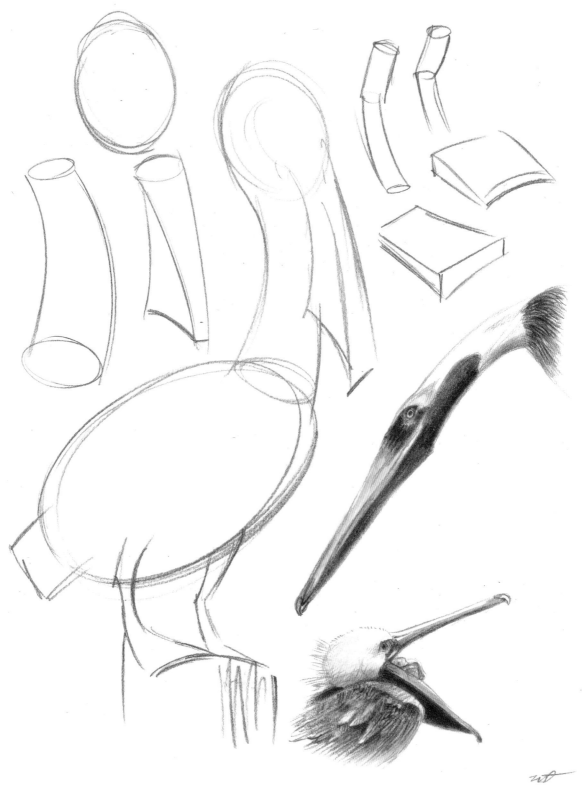

PELICAN FOUNDATION

Each animal has both an overall shape, such as a peanut body, and the individual shapes of its features, such as its ears or bill. Observe how this pelican's pouch and beak are made up of an elongated cone and a triangle. Copy this simple foundation, then refine your drawing as shown on the next page.

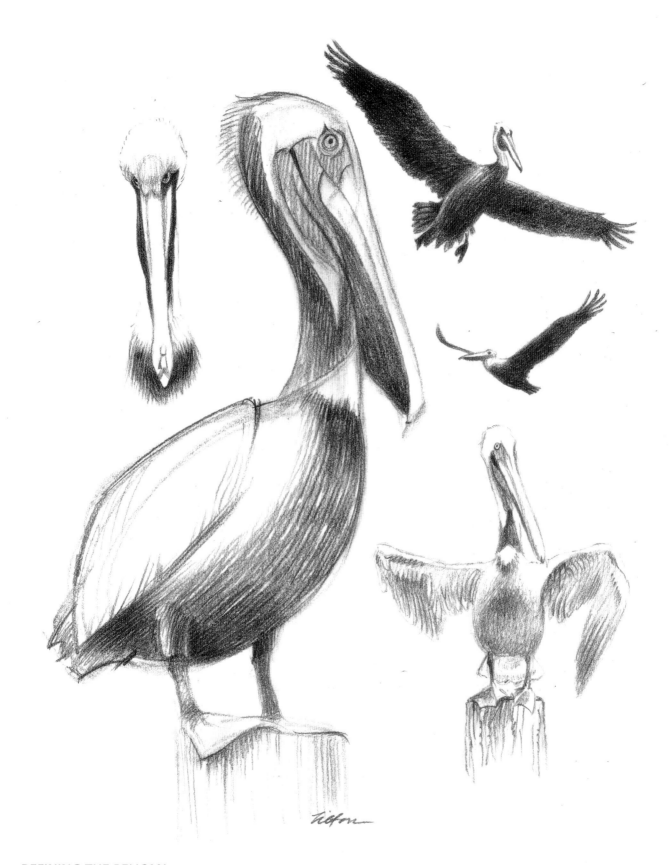

REFINING THE PELICAN

*As shown in the wing of the large pelican, you should not feel obligated to cover
every inch of your drawing with pencil strokes. A few carefully placed marks will
give the suggestion of detail, such as these feathers, for an entire area.*

Draw a Dog

The way each shape is combined with others to make an overall mass helps us identify different objects. This makes sense when you think of it; most of us have no problem telling an elephant from a mouse, or a rhinoceros from a rabbit, even though they all consist of the same four (or five) basic shapes. With that thought in mind, here are a few pages of dogs for you to copy. As you do this, you can see how easily these forms can be modified to fit other dogs, from a dog of Chihuahua size or less to a Great Dane or larger. Or, with carefully observed differences, these could become a fox, wolf, coyote—or even a hyena.

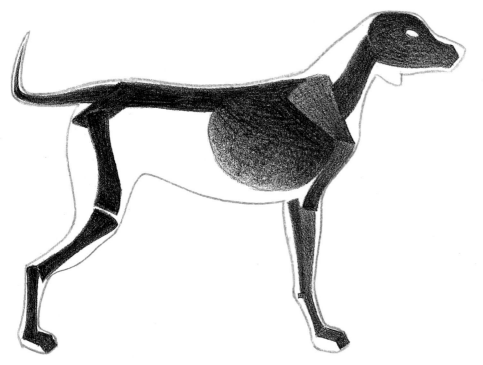

DOG SKELETON

The dog skeleton, like that of the cat previously, is done with a sketch and wash pencil. I used multiple but not heavy strokes, spraying light mists of fixative on the pencil lines after the paper felt saturated (meaning it couldn't take any more strokes). Then I added another layer of strokes over the new surface, and so on. This allowed me to progressively reach the degree of blackness I sought.

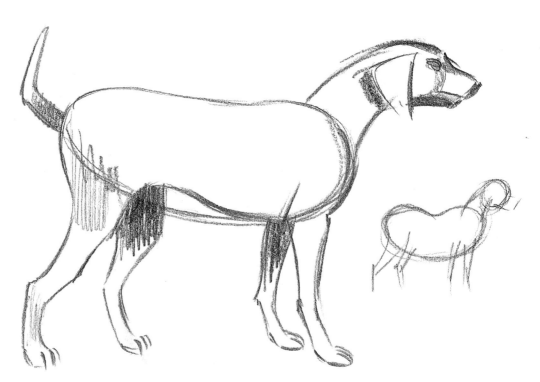

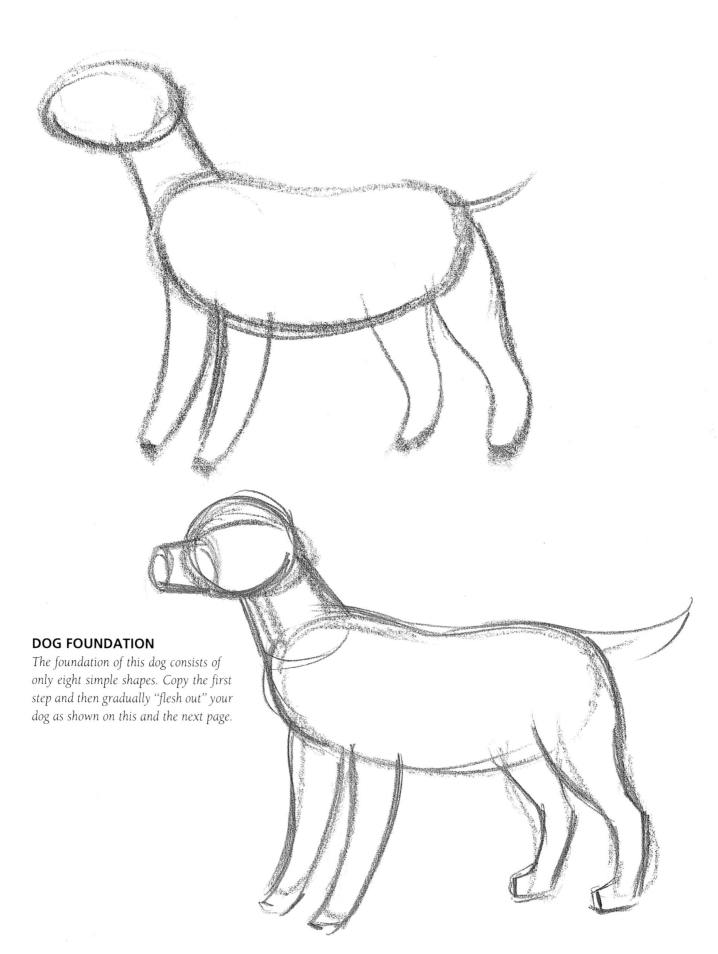

DOG FOUNDATION

The foundation of this dog consists of only eight simple shapes. Copy the first step and then gradually "flesh out" your dog as shown on this and the next page.

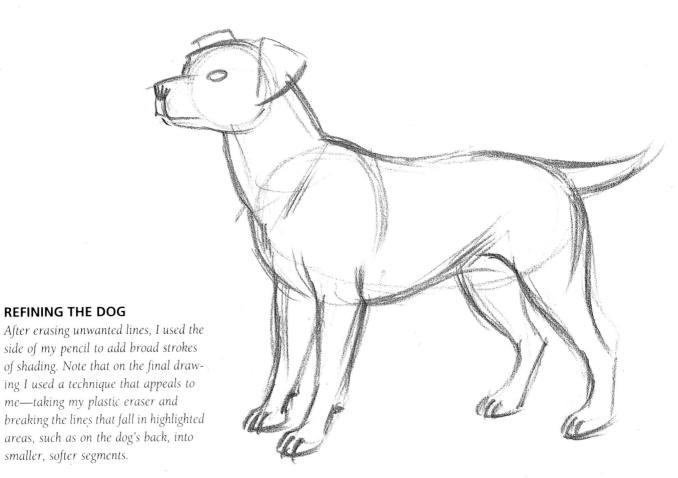

REFINING THE DOG

After erasing unwanted lines, I used the side of my pencil to add broad strokes of shading. Note that on the final drawing I used a technique that appeals to me—taking my plastic eraser and breaking the lines that fall in highlighted areas, such as on the dog's back, into smaller, softer segments.

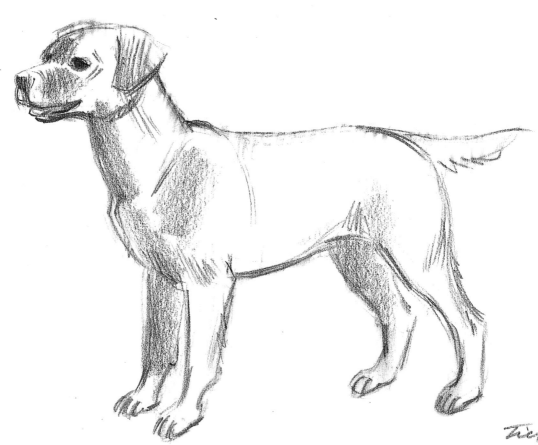

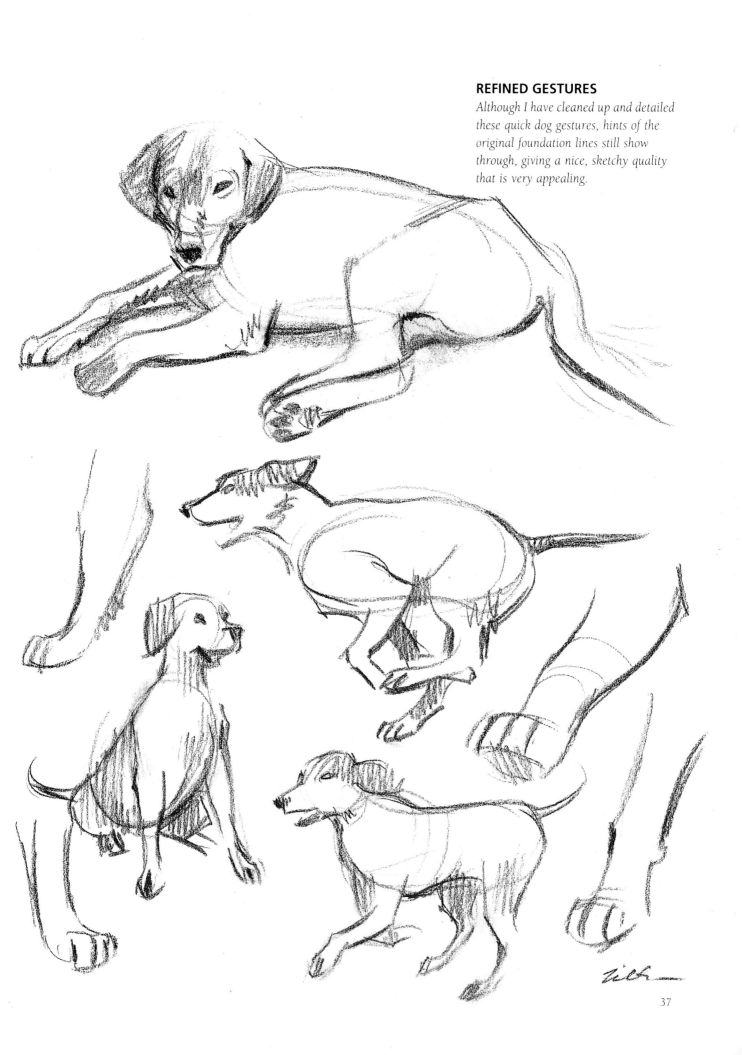

REFINED GESTURES

Although I have cleaned up and detailed these quick dog gestures, hints of the original foundation lines still show through, giving a nice, sketchy quality that is very appealing.

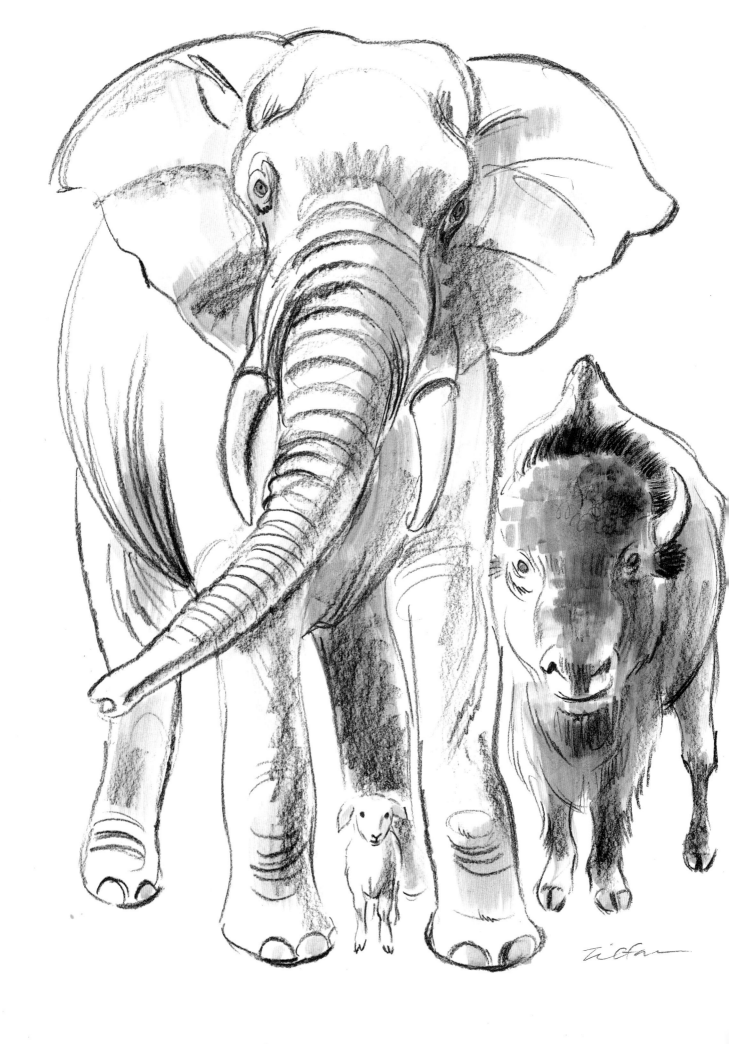

DRAWING ANIMALS IN ACTION

Once you have mastered the basics of accurately drawing each individual animal's mass and shape, you'll undoubtedly want to start sketching some on your own. If your subjects are live ones, learn to compare the scale of the animal you're drawing in relation to its surroundings and to other animals. An elephant, a lamb and a buffalo all have shapes in common, yet we know that a lamb is by far the smallest of the three. Awareness of the relative scale of anything and everything is just a common-sense matter of observation.

Learning to make such observations is essential if you wish to draw animals in action. Most animals sleep and play and, of course, fight in interesting positions. Some move slowly (like the turtle), while others (like the African cheetah) move from positions of absolute stillness and stealth to incredible speeds and changes of course. Capturing these variations requires you train yourself to observe both animal actions and shapes so you can instantly recall and relate both to the specific animal.

Using Your Visual Memory

If you are trying to draw a live animal, chances are it will not be a cooperative subject. Don't let its changing profile discourage you. By training your visual memory you will be able to look at any animal and quickly decide which basic shapes are appropriate for making your foundation sketch. With your foundation complete, it's just a matter of observing and adding details.

I previously mentioned the use of a peanut, which I use frequently in my drawing. There are many other familiar objects whose potential usefulness is also easy to visualize. To appreciate this, assemble several of the wide range of old to new bottles you have around your home, lining them up in front of you. Try visualizing in them the shapes of familiar animals. Picture in your mind a number of ordinary fruits and vegetables,

such as bananas, pears, squash, cantaloupe, oranges, apples, watermelons and gourds. Don't they remind you of certain animals?

Visualize how cans and barrels and musical instruments such as saxophones, drums and trumpets coincidentally suggest the basic structure of a number of animals. And by all means, consider footballs and other sports equipment. One's imagination does not have to stretch very far to appreciate how shapes can relate to and be the foundation of any animal drawing. Linking familiar, simple shapes to your subject will help you draw more effortlessly.

As you visualize the familiar objects just mentioned you are no doubt saying to yourself: "Of course, why didn't I think of that?" You did, I merely opened the blinds for you.

Tip

Many like to draw animals in action, so here is a good trick worth your practice. Let's say you want to draw a trotting horse. Go to a place where they trot horses, and start drawing what you can while the horse is clearly visible. Pick a particular part to watch in action, start drawing that, then add a bit more to it each time the horse runs past you. Eventually you will have a complete trotting horse. All this is surprisingly easy; it becomes second nature as an artist refines his or her drawing skills.

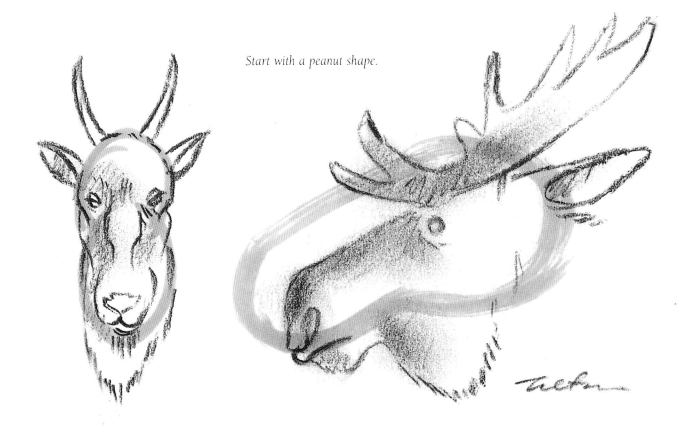

Start with a peanut shape.

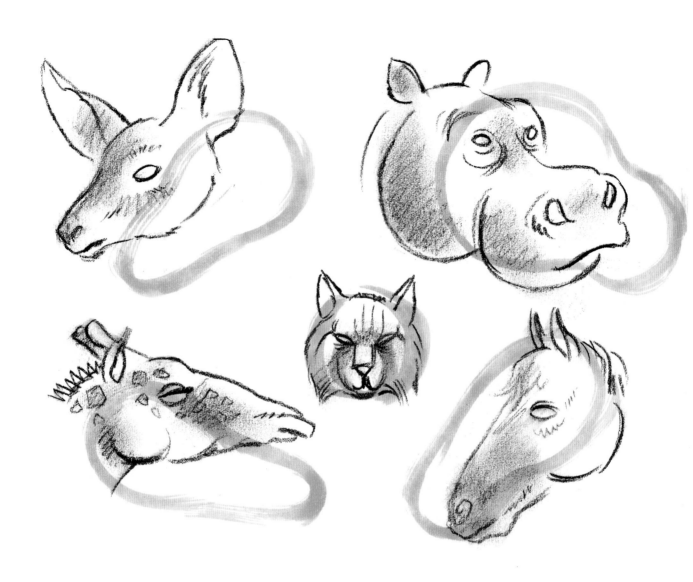

PEANUT HEADS

Look at the variety of animals you can create using a peanut-shaped head! Think of other ordinary fruits and vegetables, and the animals or animal features their shapes bring to mind, particularly potatoes and gourds.

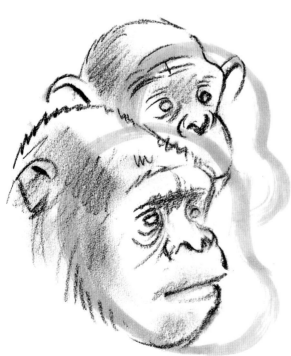

Visual Memory Exercises

At this point, to reinforce your visual memory, I recommend another exercise. Return to pages 24 and 25 and copy each of the basic shapes of vegetables and other objects. Using those shapes, visualize and draw animals in several positions. Here I encourage you to freely use your imagination. Initially, some may find this exercise easy and some may experience difficulty. In either case, simply stick with it and you will be fine. If you repeat these drawing exercises from time to time, ultimately you will find it has become second nature to visualize and translate shapes.

To minimize drawing difficulties you may experience, I also want you to repeat a page of highly simplified animals that will look quite familiar to you, and they should. They are, in fact, the same gestural drawings you worked with on page 22, except that I refined them a bit more for this exercise.

Copy them, but like other exercises throughout the book, never do it to the point of boredom. In the unlikely event you get bored or weary with any of this book's drawing exercises, set it aside for a short spell, then return, recharged, and copy them again.

Practicing these shapes will ingrain them in your mind's eye, where they will become a kind of "drawing shorthand." However, this shorthand will be much easier to learn since these shapes are already familiar to you and therefore you actually have nothing new to learn. When you feel fully at ease in drawing the items in these illustrations, you are ready to draw any animal you wish to draw.

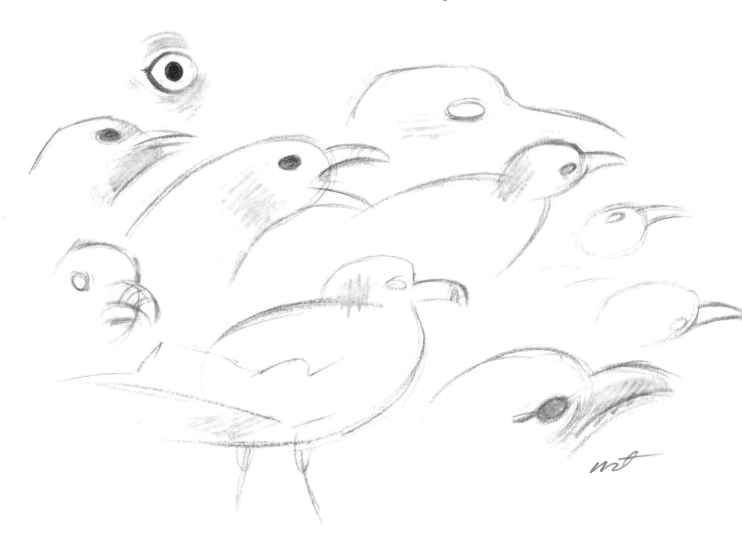

Use the basic shapes to visualize and remember animal shapes. A simple egg shape can be used to create all of these seagull sketches. Try it!

REFINED GESTURES

Repeat this page of highly simplified animals, which are developed from the same gestural drawings you copied on page 22.

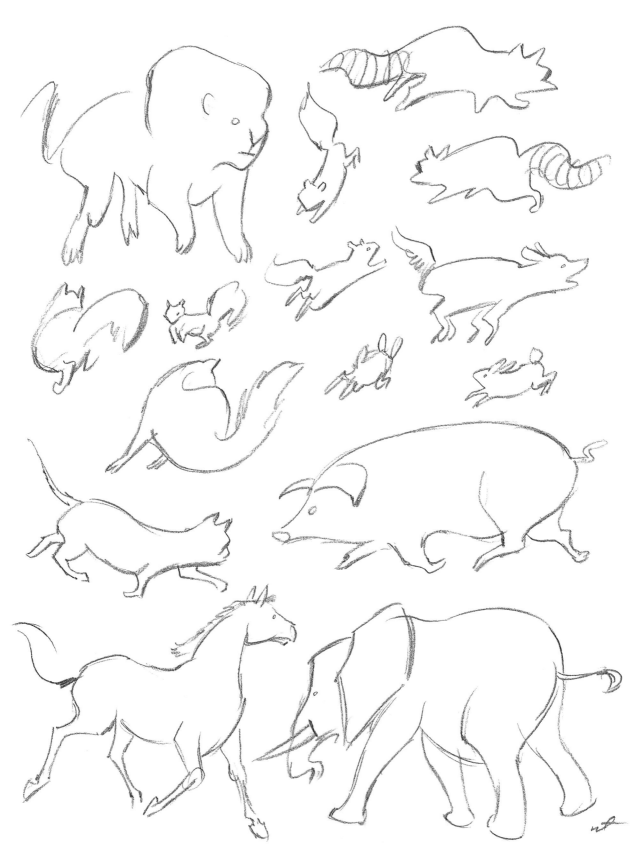

Draw a Bear

Your next exercise is to draw a walk-ing bear. Begin by sketching the sim-plified forms at the top of this page. When you have the feel of the forms, erase most of your drawing, leaving faint outlines. Then patiently draw the bear in detail.

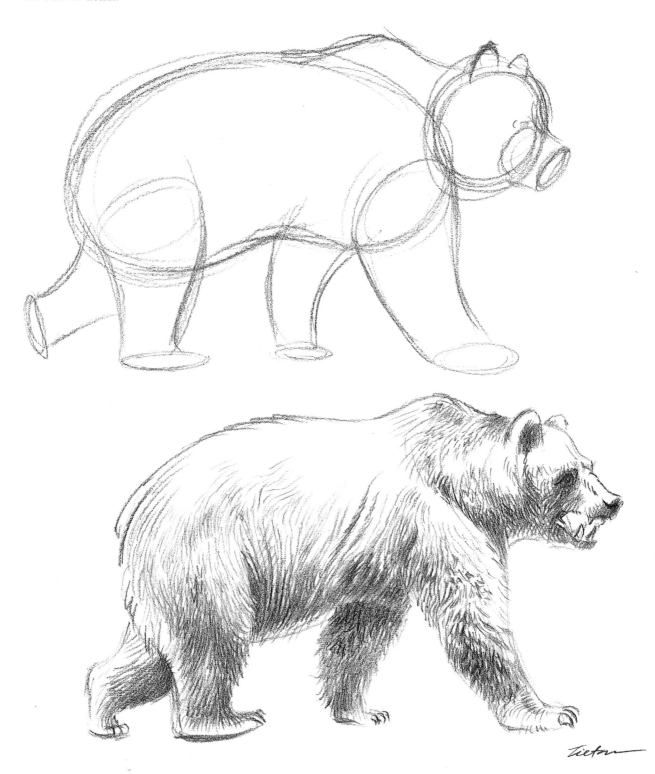

This page shows a close-up of part of the same grizzly bear. I drew an enlargement of the head and forearm so you can gain a better understanding of the kinds of strokes I recommend you make. Also, on the same page I show how overlayed pencil strokes in different directions develops different shading.

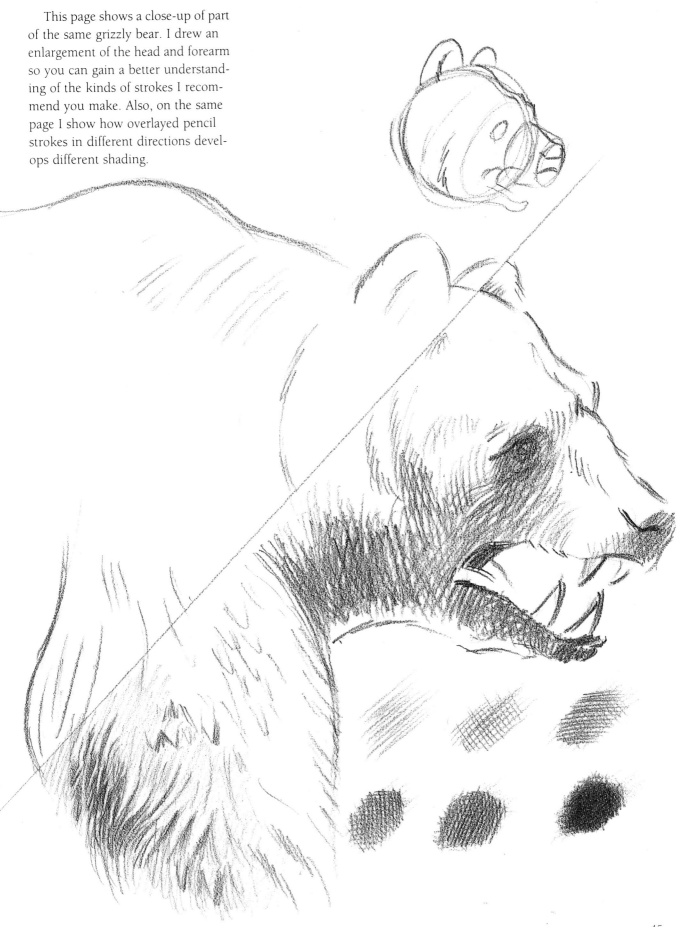

Draw a Live Bear

Having completed the last two drawings, you are ready to take a "live" challenge; that is, drawing a bear based on your own observation. As a good exercise, why not visit a zoo to draw bears from "life"? (If a zoo isn't available to you, I recommend any of the excellent videotapes about bears and other animals available through mail order, video centers, local nature stores and your library. Several are listed in the appendix.) Begin by referring to a photograph or a magazine carrying a good illustration of a bear—or refer to any of my several drawings of bears in this section.

As you study the bear it is easy to visualize a relationship between it and the common peanut shape. But you don't have to use the peanut. Other shapes like a potato, squash or gourd are equally useful. The point I stress is for you to make the visual effort to see that using forms as starting points can result in significant shortcuts. Now, whenever you feel inclined to "doodle," practice visualizing all kinds of varying shapes of items you are familiar with, then re-late them to the subject you wish to draw.

When and if possible, take your sketchbook and camera and actually go to a zoo to see live and generally unpredictable bears. At a zoo you may find bears sleeping, walking, pacing back and forth, stretching, and often "helpfully" hidden back in an artificial cave. If your arrival coincides with their feeding time—information you can easily get from zoo personnel—you will see very active subjects.

Whatever the bear's position, you will quickly see that its shape is quite similar to the shapes you've been copying and practicing. Can you see the foundation for drawing the bear's legs is nothing more than a cylinder or tube? With those thoughts in mind, take your sketchbook and start drawing. Begin by doing manageable thumbnail sketches (see page 49 for an explanation of thumbnails).

The foundation of familiar shapes in a drawing or painting is just as important and basic as is the foundation of a house or other structure being constructed. (This is a relationship I frequently refer to since a house in its various stages is familiar to almost all of us.) Any structure's foundation, with each major part related in scale to each other, is clearly the first and most vital step in construction. Just as we do not build a roof by first laying shingles out in space and then constructing trusses under them, we do not begin drawing a bear's fur coat with the thought of later adding its basic shape. The foundation of a building (or drawing) comes first, followed by the framework, with shingles (or fur) added much later.

If your basic drawing is based on a peanut, bottle or something else, do that first, then quickly add the columnar legs, a head (probably a gourd but, of course, smaller than the body). Now add two small cones or triangles to the head and you have your basic bear foundation. Take your time; this is not a speed contest. And don't let other visitors distract or intimidate you. Have confidence you can already draw better than most of them.

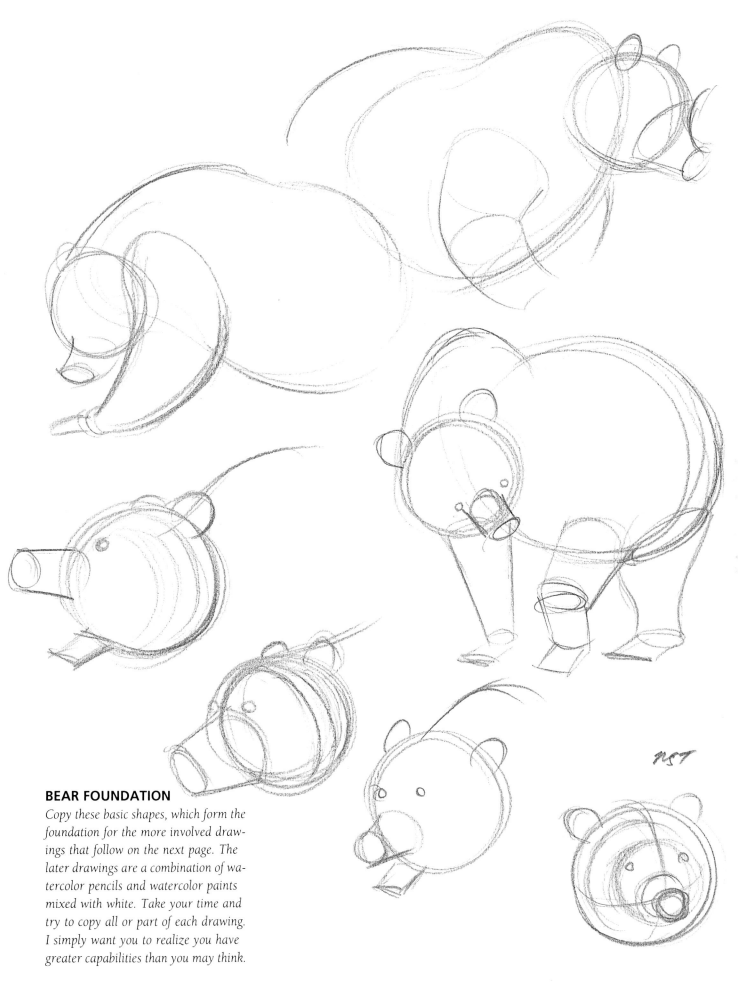

BEAR FOUNDATION

Copy these basic shapes, which form the foundation for the more involved drawings that follow on the next page. The later drawings are a combination of watercolor pencils and watercolor paints mixed with white. Take your time and try to copy all or part of each drawing. I simply want you to realize you have greater capabilities than you may think.

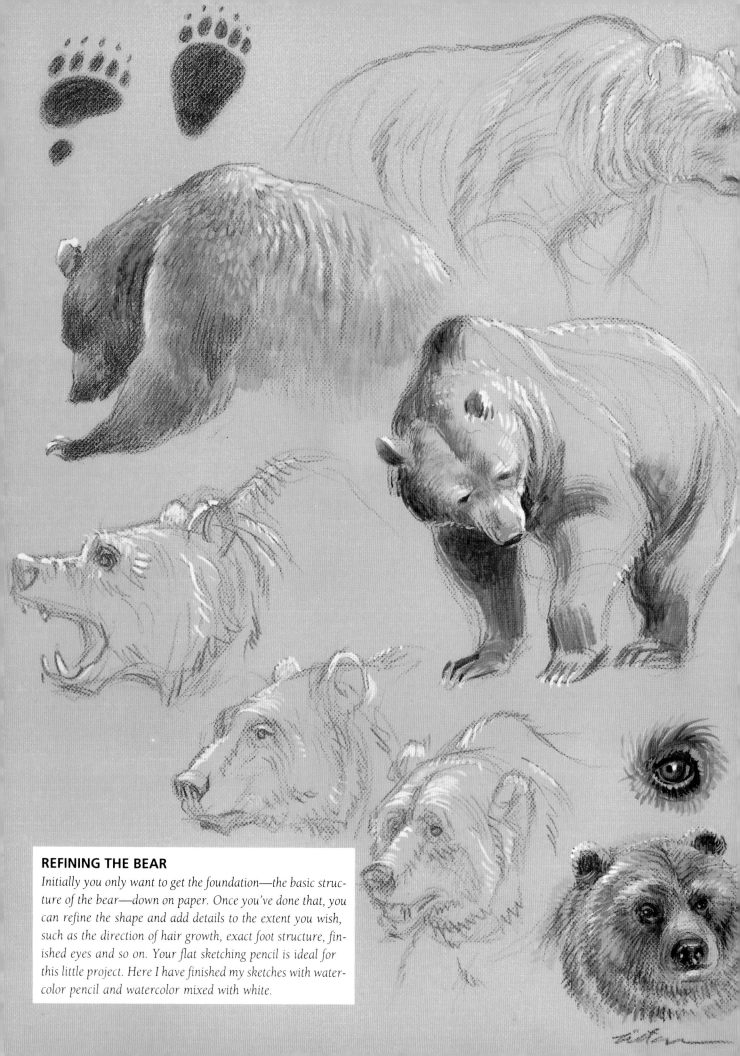

REFINING THE BEAR

Initially you only want to get the foundation—the basic structure of the bear—down on paper. Once you've done that, you can refine the shape and add details to the extent you wish, such as the direction of hair growth, exact foot structure, finished eyes and so on. Your flat sketching pencil is ideal for this little project. Here I have finished my sketches with watercolor pencil and watercolor mixed with white.

Thumbnails

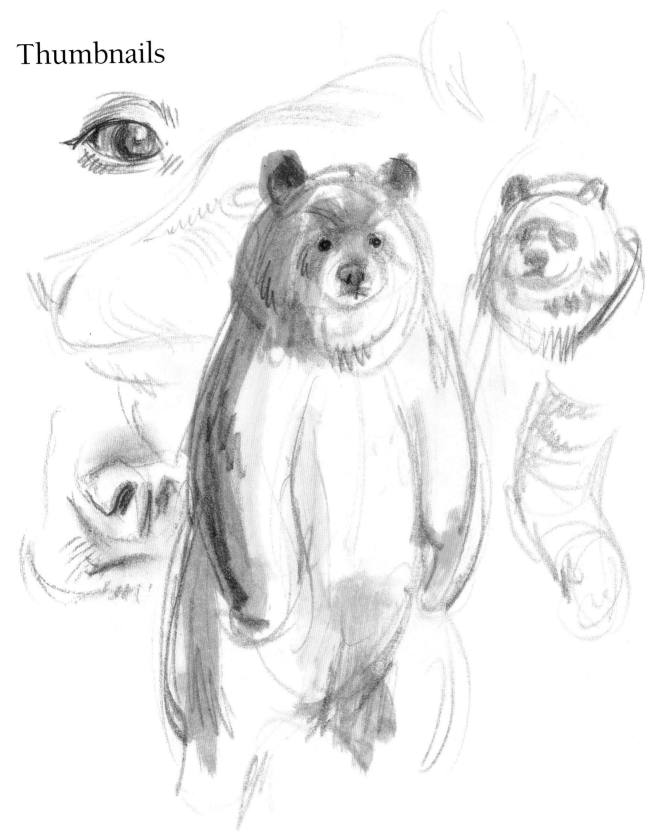

Let me digress to explain thumbnail sketches and their value to artists. Thumbnails are small sketches, typically a few inches square, that artists develop while planning a more complete drawing or painting. Often thumbnails appear to be doodles or something like shorthand. They are visualizations of how a larger, completed work of art might be composed. Artists use thumbnails to plan light and shadow (as I have done with the standing bear shown above), possible color schemes and so on. Because they are great time-savers, I sometimes do as many as fifty of these little planning sketches prior to beginning work on a major painting.

Draw a Polar Bear

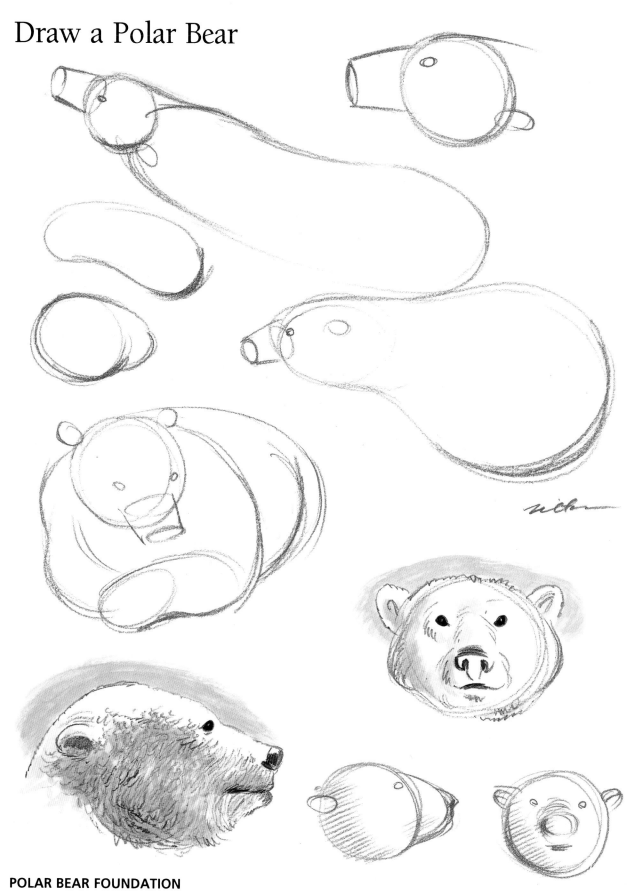

POLAR BEAR FOUNDATION

*A peanut, a circle and a tube are all that are needed to draw
the foundation of these polar bears.*

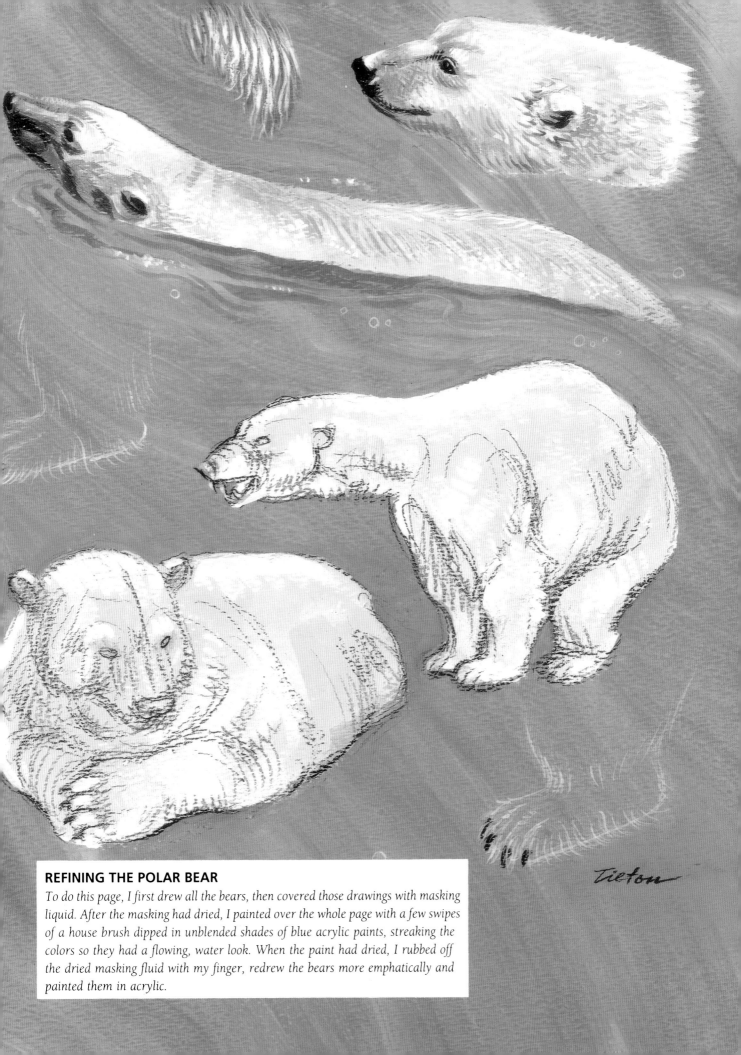

REFINING THE POLAR BEAR

To do this page, I first drew all the bears, then covered those drawings with masking liquid. After the masking had dried, I painted over the whole page with a few swipes of a house brush dipped in unblended shades of blue acrylic paints, streaking the colors so they had a flowing, water look. When the paint had dried, I rubbed off the dried masking fluid with my finger, redrew the bears more emphatically and painted them in acrylic.

Draw a Squirrel

You are now ready to copy the "teach yourself" examples that follow. First do all the squirrel drawings you can, followed by the cattle examples. I want you to take on these projects simply to surprise yourself; they look difficult but are not. The fact is they are only somewhat more refined than the rabbit head you did when you started this book, demanding only time and patience on your part.

Begin by drawing the structure lightly, then carefully erase anything you consider extraneous. Only enough of the foundation to serve as a guideline is required. With the foundation established, simply draw patiently, resting every now and then because detailed drawing is often hard work. (If some of this detailed drawing seems too challenging, make a memo to go back to these examples when you have gotten further along in this book. Then make certain you go back and do them!)

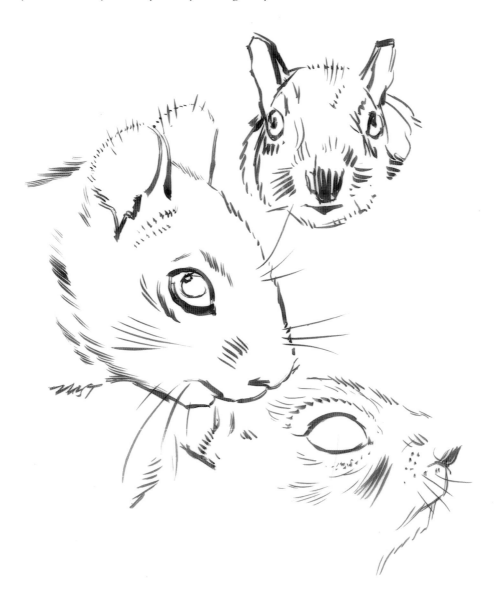

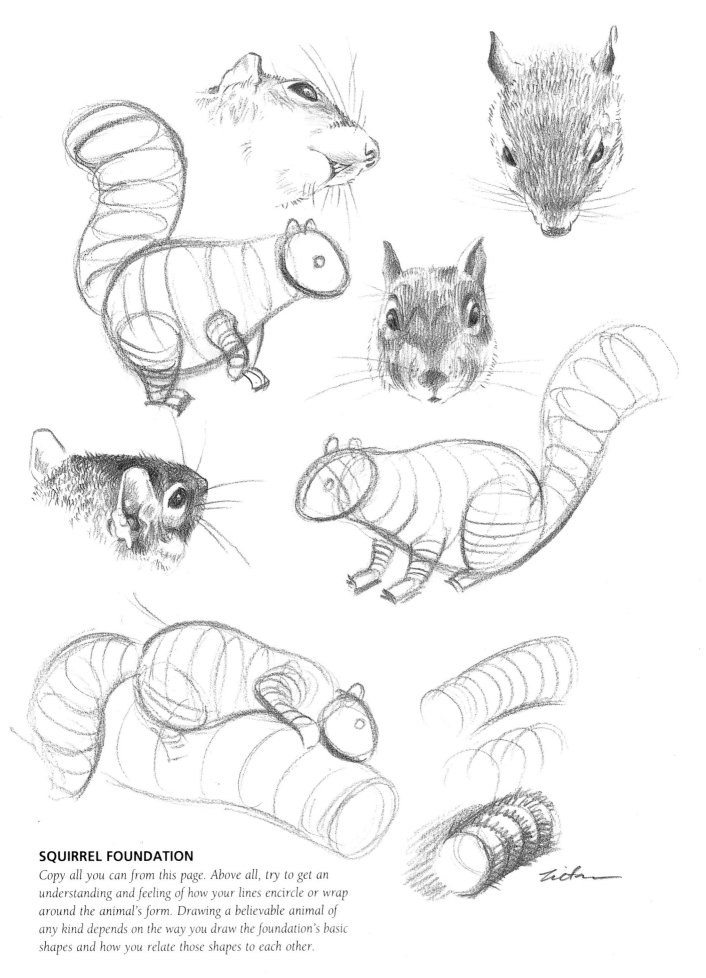

SQUIRREL FOUNDATION

Copy all you can from this page. Above all, try to get an understanding and feeling of how your lines encircle or wrap around the animal's form. Drawing a believable animal of any kind depends on the way you draw the foundation's basic shapes and how you relate those shapes to each other.

REFINING THE SQUIRREL

With the pencil drawing completed, I lightly fixed it, then proceeded to add very little watercolor, using a no. 6 round watercolor brush. To make the bark and lichen look realistic, I added white gouache to the watercolor, the result being an opaque color. On the rest of the drawings I used only a hint of watercolor, allowing the pencil lines to show through.

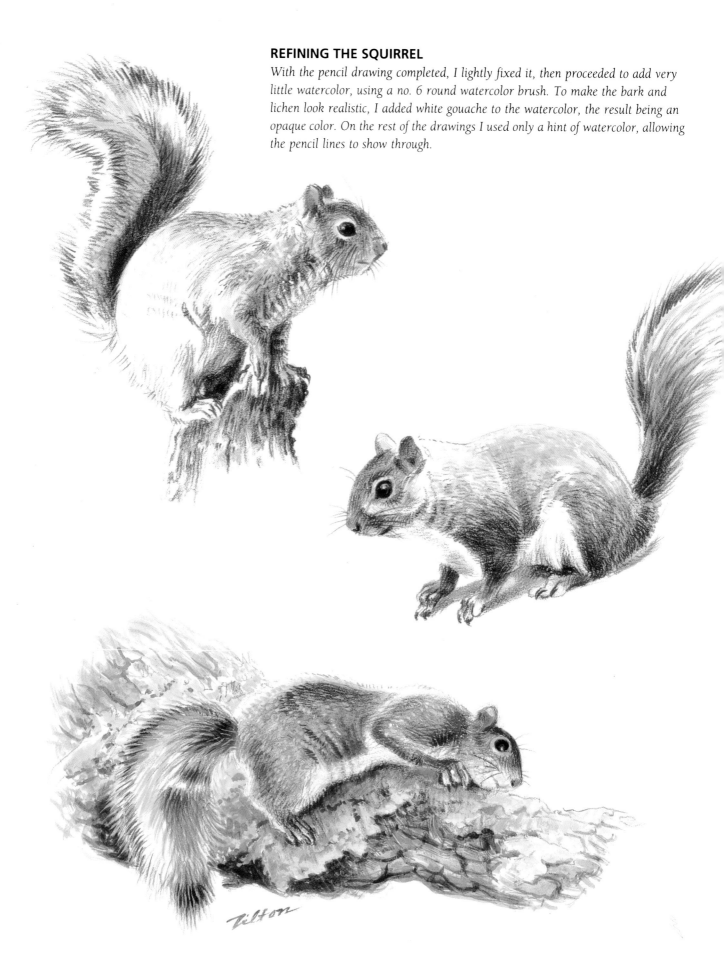

Draw a Cow

The next three pages of cow illustrations help you better understand how to compare your drawings to building a structure. Once you can visualize that, the idea will help you draw any animal doing anything. Here's how. Each animal has a roughly similar body consisting of a lower part (like our hip and stomach area) and an upper part (which contains the ribs, shoulders and neck). Specific shapes vary, as does the mass. Somewhat similarly, most houses are more or less common in their shape—they have floors, levels, rooms, walls, ceilings—but each has differences in dimensions, features and mass.

Once you have drawn the basic foundation of a cow and its major parts, you should be able to modify it to represent any kind of cow (or bull). You can change any outer information and details you wish just as a building's basic foundation essentially remains while the facade and externals often get extensive face-lifts. All you need to do with your drawing is carefully observe the differences between a Holstein, a Guernsey and a Brahma, to cite a few examples.

COW FOUNDATION

Although this cow foundation may look complex at first, it is only the basic peanut shape with a series of tubes and cones for neck, muzzle and legs.

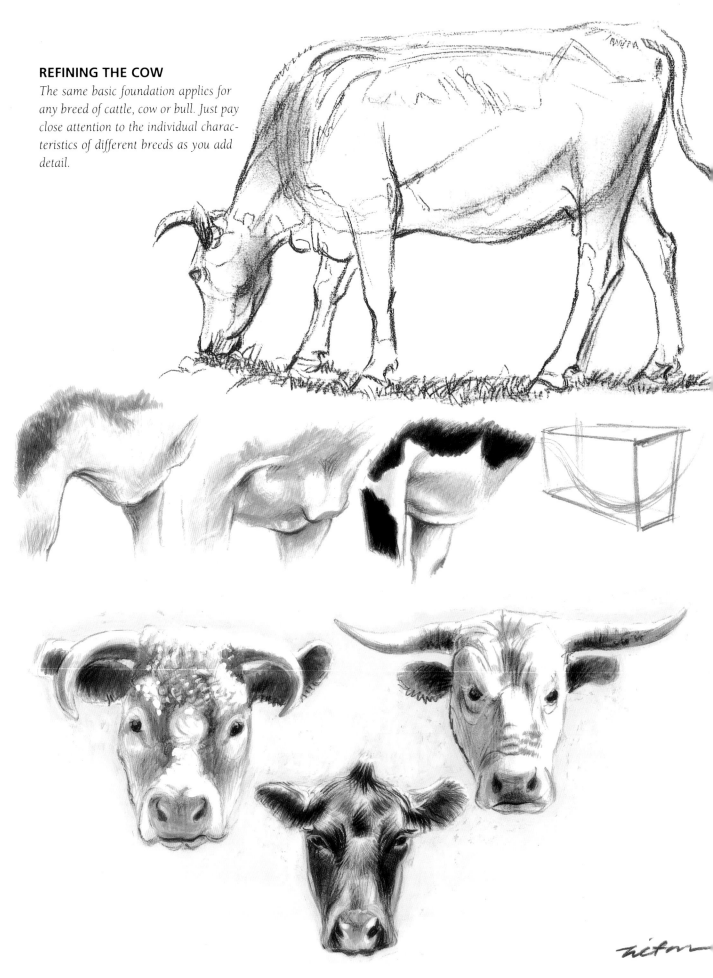

REFINING THE COW

The same basic foundation applies for any breed of cattle, cow or bull. Just pay close attention to the individual characteristics of different breeds as you add detail.

The Drawing Formula

To summarize the working formula for drawing and painting animals, begin with the body shape and mass (the foundation), and only then refine it, adding other details in correct dimension, shape and mass. Isn't that easy? Repeat it to yourself every time you want to start a drawing because you can't miss with this formula. With the simple but vital foundation established first, careful observation and patience will get the details right.

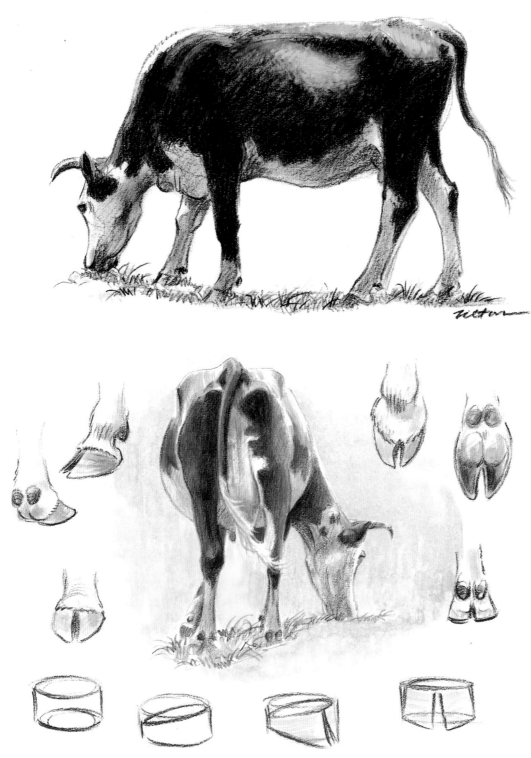

Using the ideas just presented, copy all the figures shown on these three pages of cattle.

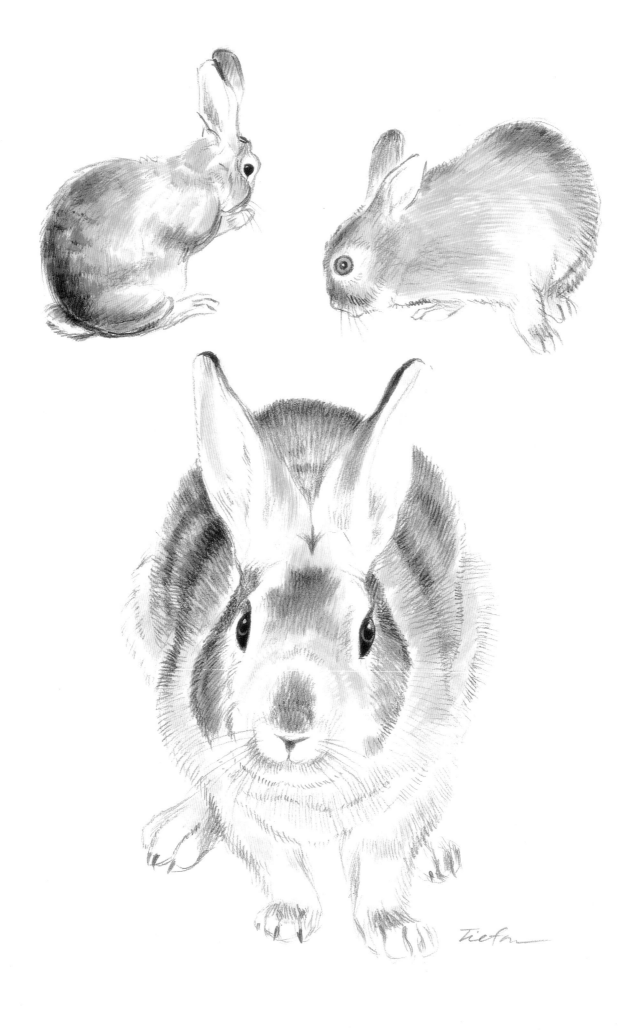

Chapter Three

IMPROVING YOUR SKILLS

In the last chapter I encouraged you to take a field trip to a zoo in order to learn more about drawing animals. In this chapter, you will discover many, many other sources available to you in your quest to improve your drawing skills. Why not sketch at a nearby farm? How about checking out local museums? Practicing your drawing skills can even be as easy as ordering a wildlife video produced by a reputable television nature program.

In addition to this information, I will continue to provide you with examples to copy. Don't be intimated by the amount of detail I've added. If you have practiced the earlier exercises repeatedly, I know you are ready for it. In fact, copying the rabbits on the left may seem beyond your skill, but you will amaze yourself. They are actually easier than the squirrels and cows you have just finished. Refining the rabbits simply demands more discipline to draw all those hairs radiating around the body. Copy the following rabbit foundation, and then give this finished drawing a try.

Draw a Pet Rabbit

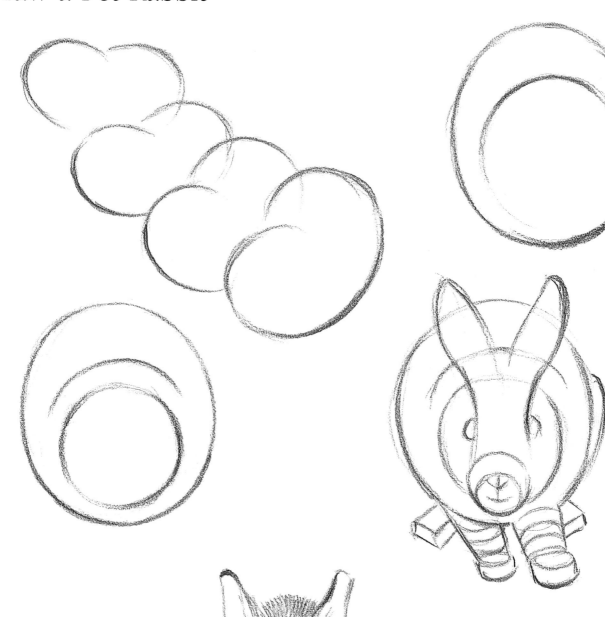

If you have a pet or pets, you have a fine, on-hand model or models for your drawing practice. Lacking your own pet, consider visiting friends who have a pet or a farm and/or visiting your local library or bookstores for illustrated books and magazines about animals. Veterinarians and nature stores are excellent sources.

As an example of using pets, this series of drawings for you to do was based on a pet rabbit owned by my grandchildren. Please copy all these drawings, including the rabbit on the chapter opener.

RABBIT FOUNDATION
The upper left sketch shows how the basic peanut shape is rotated as the rabbit is seen from a side view all the way to the full frontal view shown at left. Copy these drawings.

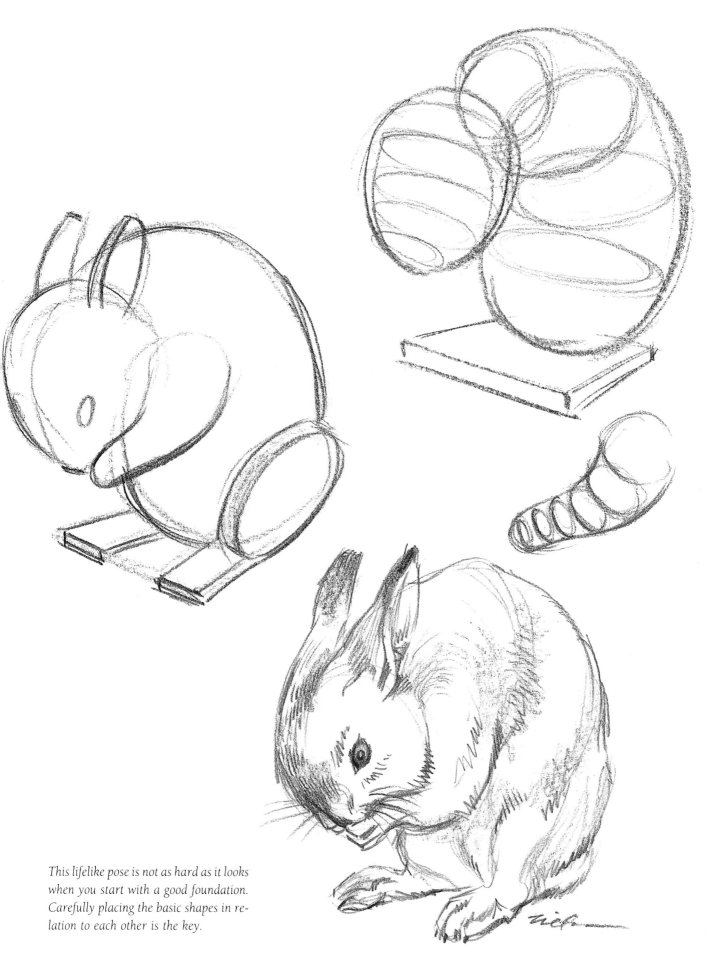

This lifelike pose is not as hard as it looks when you start with a good foundation. Carefully placing the basic shapes in relation to each other is the key.

Print Resources

Many magazines specialize in articles about animals. Some wildlife magazines concentrate on specific animals in the wild: bears, deer, elk, turkey, pheasants, to cite some examples. Similarly, many magazines feature domestic animals: horses, cattle, dogs, cats and so on. In addition, veterinarians often stock a wide selection of well-illustrated, specialized booklets and pamphlets concerning specific domestic animals and pets.

Most states publish pertinent nature and wildlife magazines about their state's flora and fauna. Request these publications by writing the state chamber of commerce. If your nearest public library is on a computer system, it can furnish current mailing addresses. Your State Wildlife Association no doubt has the addresses of all similar activities of other states.

I look for unique, high-quality magazines that feature professional wildlife art, and among these I have a single favorite. For consistent, high-quality art, and articles about animal drawing and painting, nothing to date matches or exceeds *Wildlife Art*, the art journal of the natural world. (See appendix for addresses and important copyright information.)

You can learn a lot by trying to *exactly* copy examples of work by the many fine animal artists whose work is published in art magazines and books dedicated to wildlife art. (See appendix for a listing.) I say "exactly" because, if you do, you will make real progress and you will learn how a particular artist produced a specific

The tiny details shown in these sketches of an eastern bluebird would be hard to capture when drawing from a live model. In instances like these, photographic references are an invaluable resource.

piece of work.

Throughout history famous artists have copied the work of others to learn how something was drawn and painted and to understand the techniques required to produce specific examples.

However, although said before, remember this very important guidance: Never claim your copy of another's work as yours, and never, never market it as your original. At a

minimum, doing so would be unethical. Legally, if you copy and sell the work of a living artist or photographer without his permission (preferably in writing), you can be heavily prosecuted for violation of copyright laws. (I have, however, made an exception with my original art reproduced in this book. This is a copy book, after all!)

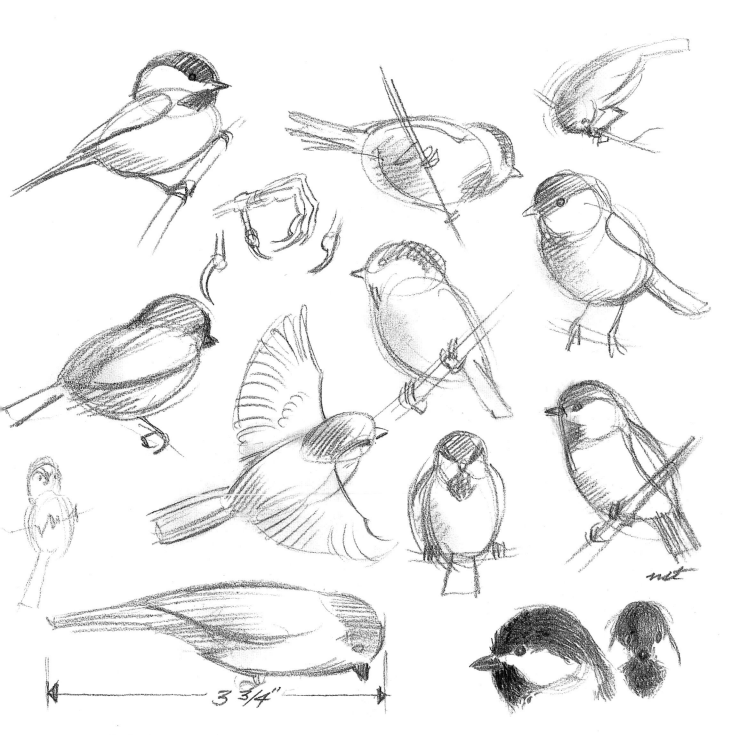

3 3/4"

Let me add a few last words of caution about using the artwork of others for your own reference. There is much superb animal art available in books, mechanical reproductions (commonly known as prints), and films of artists' works. Most is absorbing to look at, but please remember you are looking at that artist's interpretation of what he or she was seeing. What an artist sees is often personalized and edited somewhat to make a better picture. Even worse, too often artists are basing their work on the work of others, so the detail is secondhand or more.

CHICKADEE SKETCHES

I have captured as much information as I could while drawing these quick little birds. To fill in vague details, I could now turn to one of the many wildlife art resources available.

More on Sketching and Visualization

Get in the habit of having a convenient sketchbook with you anytime you will be near animals. Enjoy and avail yourself of the work of others, but for accuracy of detail, your best source is your own first-hand observation and good-quality photography, preferably your own, with annotations in your sketchbook regarding actual coloration. When I want to be certain of correct color information I go to natural history museums to see actual specimens, or to the nearest zoo to see the original example in the flesh.

In your sketchbook, try to link familiar shapes with the animals you want to draw. This is where *visualization* becomes so important. Whenever you have an opportunity to avail yourself of good reference sources, practice visualizing and linking animal features with the familiar, look-alike objects I previously mentioned. The more you do this, the easier it gets.

You could have several pages of your sketchbook devoted to each animal, or even a separate sketchbook for each animal. Your sketchbook's primary value is in making quick sketches and notes of subjects and details, as you observe them. As you gain experience, you will discover these on-the-spot drawings will often serve as the stimulus and the basis for finished work.

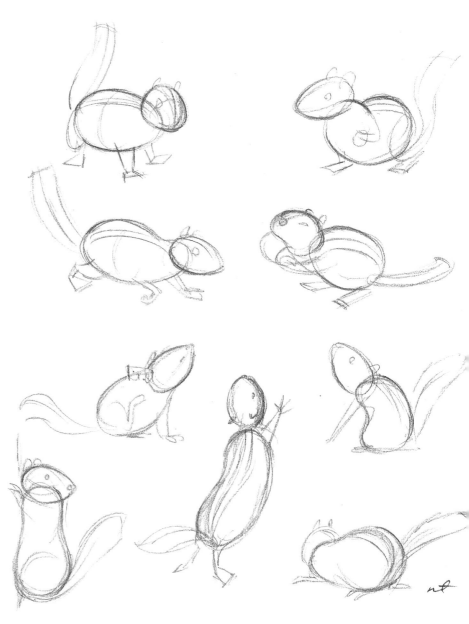

CHIPMUNK FOUNDATION

Here is a typical page of foundation sketches I made while watching a chipmunk in action. Recording the animals around you in your own sketchbook anytime you have the opportunity will avail you of the most valuable drawing resource: your own firsthand observation! Copy all these chipmunks.

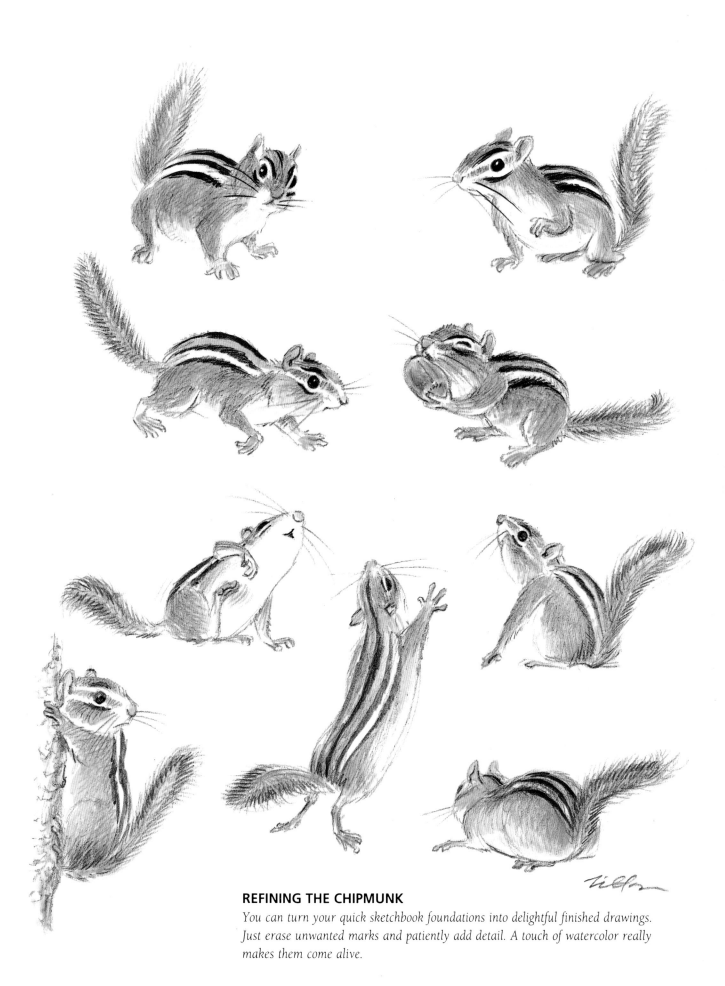

REFINING THE CHIPMUNK

You can turn your quick sketchbook foundations into delightful finished drawings. Just erase unwanted marks and patiently add detail. A touch of watercolor really makes them come alive.

Your Backyard

You may find a miniature zoo in your backyard, one with chipmunks, rabbits, squirrels, chickadees and other wild things waiting to be drawn. Set up some feeders or a bird bath near a window where you can sketch comfortably and you will never be lacking in live subjects to draw.

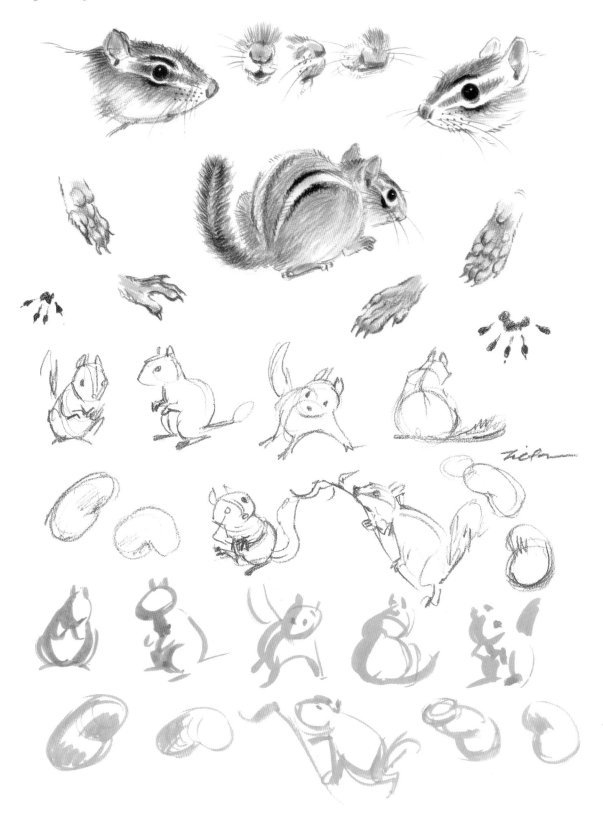

Museums, Zoos, National Parks

As I've mentioned, zoos are good, often overlooked resources, even for printed materials. They are worth visiting throughout the year, so when you travel, make the effort to include them on your itinerary (your own zoo membership may even be honored). Zoos give you an opportunity to observe live animals in a usually accurately replicated habitat, as well as in their natural coloration. Zoos are an invaluable resource for getting the correct habitat and live color of a specific animal.

The United States has many outstanding zoos, as do many foreign countries, each with different displays featuring special habitats and animals. This is particularly true of rare and threatened animals like the panda. Zoos often have their own posters, pamphlets and postcards depicting their popular rare exhibits. These are all worthwhile additions to an artist's resource files.

Also check with your state's Museum of Natural History to obtain the names of nearby legal, smaller collections of endangered and exotic animals. Seek out the specialized wildlife areas that feature large members of the cat family, bison and buffalo, members of the deer family and so on that are hard to find in the wild. Most zoos and game parks will allow you to take photographs, but always get permission first and observe all safety rules and cautions required by the specific zoo.

The United States is also blessed with great and small national parks, such as the world-renowned Yellowstone National Park. In addition to national parks, many states have spectacular, easy-to-see assemblies of wild animals. Such places are often featured in *National Geographic* magazine, which consistently offers superb outdoor photography. If you are interested in what a particular state has to offer, contact the respective State Wildlife Federation. Reference sections of public libraries are fine sources for addresses as well as guides to publications about animals.

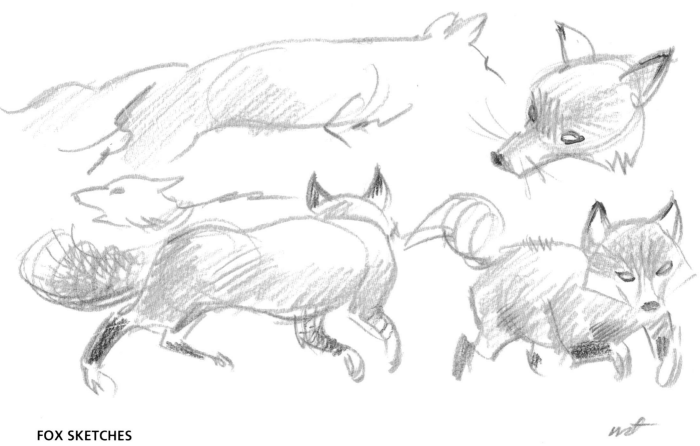

FOX SKETCHES

Don't forget your sketchbook when you visit zoos, national parks and natural history museums, where you will be able to expand your observations to include wild and even extinct animals.

Draw a Fox

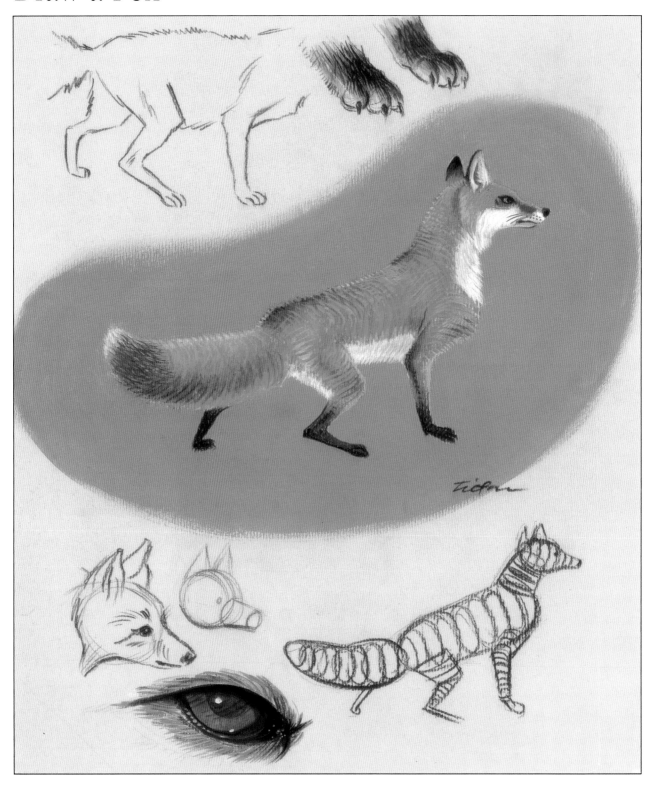

Foxes are easy to see in many areas, but they don't wait around very long. This page of illustrations is based on museum specimens and skins. I first used a charcoal pencil, then sprayed a light mist of fixative, and finally added the color with gouache. Note that the body is done in the same manner as the squirrels you copied earlier. Now please copy these foxes.

Draw an Antelope

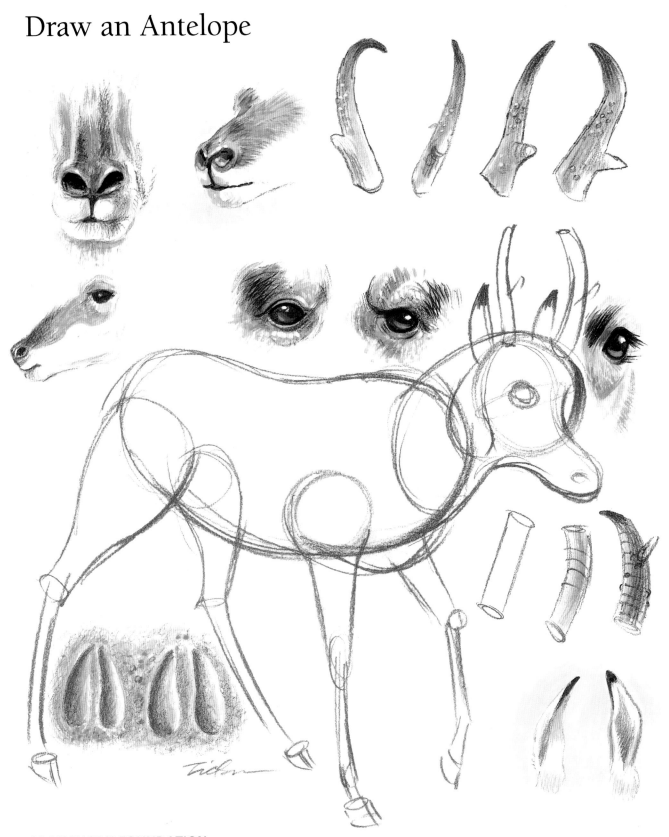

PRONGHORN FOUNDATION

On the next few pages I offer a series of America's pronghorn antelope for you to copy. Born in Wyoming, I grew up with these gentle speed demons. I include many details so you can add more to your drawings or paintings if you wish. The color on this page is watercolor over pencil drawings.

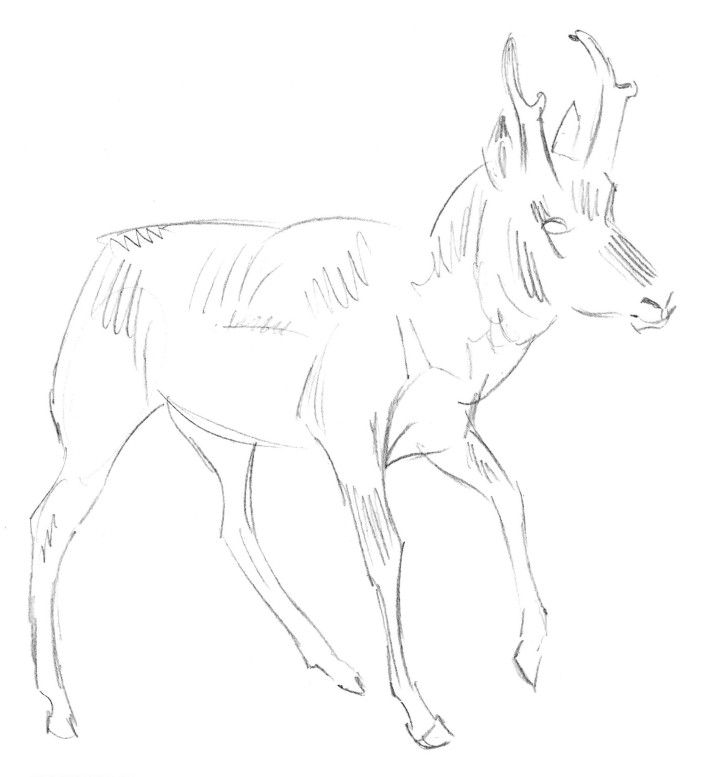

PRONGHORN SKETCH

This sketch is a slight refinement of the original foundation drawing, this one indicating hair growth and giving a clearer idea of the profile of the antelope.

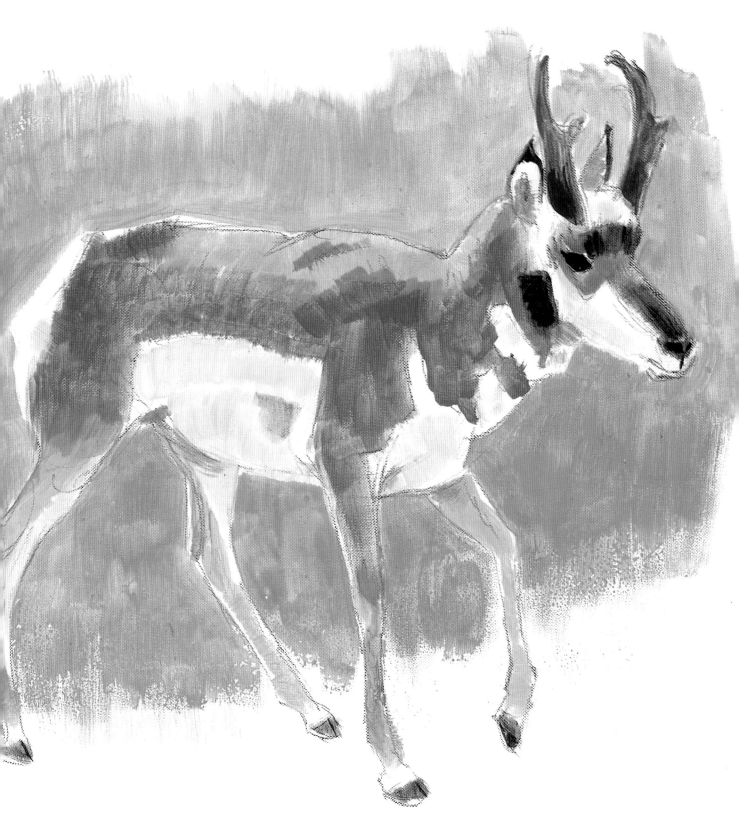

REFINING THE PRONGHORN

In this drawing, you see only a faint indication of pencil lines. Over those I applied Golden acrylics, using ⅛-, ¼- and ½-inch synthetic brushes. I used touches of Mars Yellow and Mars Black, plus Titanium White. For the background, I used a mixture of Golden's Azo Yellow and Payne's Gray.

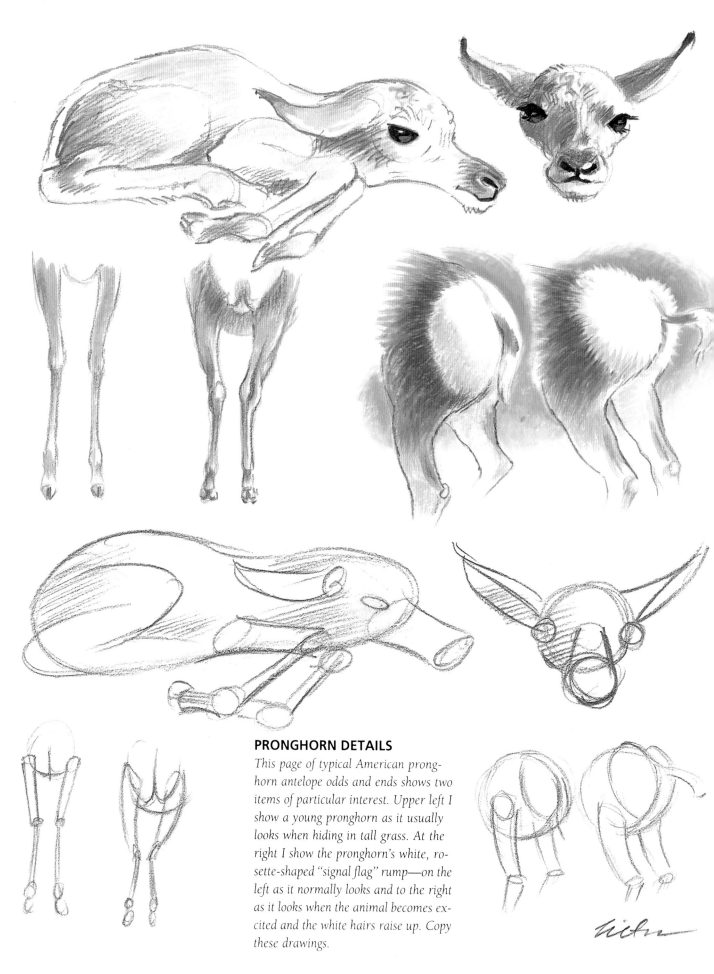

PRONGHORN DETAILS

This page of typical American pronghorn antelope odds and ends shows two items of particular interest. Upper left I show a young pronghorn as it usually looks when hiding in tall grass. At the right I show the pronghorn's white, rosette-shaped "signal flag" rump—on the left as it normally looks and to the right as it looks when the animal becomes excited and the white hairs raise up. Copy these drawings.

The Camera

The gathering, sorting and convenient filing of accurate reference material, and knowing where to look for more, is absolutely vital for drawing and painting animals. One of the most valuable tools for the gathering part is a camera, preferably one capable of taking reasonable close-ups and usable telephoto shots.

Your camera need not be expensive, but it must be reliable. A good-quality, dependable and easy-to-use new 35mm camera, preferably auto focus, represents about the same investment as a good television set, with each additional lens being comparable to buying a VCR or CD player. A camera will serve you best if it has a 2.8 or faster 50mm lens. In addition, you will be well equipped if you acquire a variable zoom lens, a 70-200mm with the fastest lens you can afford being a wise choice.

These two lenses offer you ample range for most situations, and with the addition of a device called a 2 × extender you can inexpensively double your lens power to 400mm. With such a lens you can bring clear images of distant animals and birds close enough to take worthwhile reference photographs, even in lower light. Unless you are exceptionally steady, a unipod or tripod is essential to minimize "camera shakes."

My eighteen months in Africa provided me some unequaled opportunities to observe and draw firsthand many species of wildlife. Unfortunately, I missed several great occasions because, of necessity, I violated a golden rule for anyone interested in doing animal art. I didn't have my camera with me! The real reason for no camera: I was stationed in a then-Communist country and for some time did not have my mandatory, official photography permit with me.

It sounds like Loch Ness stuff, but in one instance I watched a herd of a hundred-plus sable antelope from about five hundred yards. What magnificent and very large animals! Later, permit acquired, I got a few useful shots of the same animals. At another time I was trying to get close to what looked like a big herd of cattle. Wrong! The herd was at least a hundred baboons and suddenly they were on all sides of me. I truly felt threatened with the barking and furtive, scary looks, particularly of the big males (called "dogs" because of their dog-shaped heads). Then the baboons began screaming as they charged past and alongside me, accompanied by all kinds of animals and birds. The ground literally shook and the noise level was extremely high. I believed it was an earthquake, so I stood transfixed, backed against a very large tree. Suddenly I was surrounded by a herd of stampeding elephants. It was like being in the middle of tanks on an assault. Several elephants passed quite close by, but as I had no camera, my only record of the incident is a large painting I did later, painted from the deep and vivid imprint the incident left on my mind.

I lived very near the Niger River where large hippos and crocodiles could easily be seen up close, yet I have only a few quality photos of them. And by the way, for some time I had a pet baboon I had bought for fifty cents from an ignorant and abusive resident. Eventually I gave it to the country's national zoo, but prior to that I had a great model right in my home. After I got my camera permit, I was able to take a few photos of my baby baboon, as well as close-ups of lions, warthogs and my pet hedgehogs.

Back to the camera, reliable camera repair stores often have excellent used models that the store has checked over and reconditioned as required. *Caveat emptor*—let the buyer beware—is very appropriate here. The safe rule is to do business only with a reputable store you know or one that has been highly recommended to you. If you can do so, buy the newest, latest, state-of-the-art camera. Photography, like the entire communications field, is advancing rapidly. It only takes the sale of a few of your good paintings of something based on your own photographs to repay your investment.

Film

Your cheapest investment is quality film. For some time my preference has been Fuji film, the choice of many professional artists. I especially like Fuji 400, which allows fast photography from early morning to sundown. Regardless of the film you use, always have enough on hand since what we are photographing (constantly changing light, clouds, weather conditions) will never again occur precisely the same in our lifetimes. The moment is fleeting, lost forever except on your film. Film is actually your least expense.

Videotapes

Clearly, it is best to see wildlife in its natural habitat, but some of us find that difficult. Watching wildlife videotapes is the next best thing to observing animals in the wild, firsthand. Good videotapes provide a most comfortable way to observe an animal in its natural habitat, exhibiting its unique behavior, and, often, interacting with members of its species. It is vital to me as an artist to understand how an animal I am painting walks, runs, yawns, growls, changes moods, sleeps and so on. As I paint I mentally visualize how the animal turns its body, holds its head, perks up its ears to show alertness, and so on. Videotapes provide this type of insight and much more. With "pause" and slow-motion controls, one can gain considerable information about how animals, such as the pronghorns shown on the preceding pages, move and don't move, and about their changing environment at specific times of the year.

Local public broadcasting stations and cable channels normally carry some wildlife programs. If you aren't familiar with them, why not contact your local television station and learn which programs you receive? I have taped close to one hundred interesting wildlife films on my VCR. After some months of taping programs about animals I became more efficient—I learned to reserve a tape for deer, another for bear, another for buffalo and so forth. I have also purchased several of the many fine, commercial wildlife and wildlife art programs (the appendix lists reliable mail order 1-800 sources for recommended videotapes), and I have bought or recorded the works of several prominent wildlife artists, learning something from each. I have found that using videotapes is a handy, inexpensive, rapid reference system. If you do not own a VCR, don't be depressed. Just remember that famous artists were producing great animal paintings and drawings long before cameras were developed.

Video Camera

Many artists use a video camera and find it a valuable tool. They are ideal for extensive trips to national parks or places like Africa, Alaska, etc. Seek the best lightweight version you can afford as well as the most up-to-date and easiest-to-use version. Above all, it must be reliable.

My video camera is easy to use with its "you get what you see" mini-TV-like screen. I find it fine for both close-up and action shots. With included attachments one can play its 8mm film on TV. This allows artists to record what they wish, then return home and literally draw from life. When you are ready to get one of these or similar cameras, take your time, shop around and, if at all possible, talk first to someone who owns the model you are interested in.

Museums and Taxidermists

Many artists who take photographs for reference use black-and-white film, wisely relying on actual specimens and skins they borrow from museums for color references. Each museum has its own rules, so it is definitely worthwhile to cultivate good working relationships with museum staff members. My time spent at the museum in my area is always productive and the professional staff is extraordinarily helpful.

Get to know your local taxidermists too. You can learn a lot from a good taxidermist, and many will loan you mounted specimens. Note, though, some words of caution: There are both very fine and very poor taxidermists. The latter tend to mount animals in unrealistic poses and use accessory foliage and settings that do not accurately relate to the habitat of the specimen. If you see taxidermy work you believe is well done, find out who did it and turn to that individual.

Sketches like these could be made from a videotape you shot at a zoo or national park, or from observing mounted animals at your local natural history museum or taxidermist.

Draw a Rhino

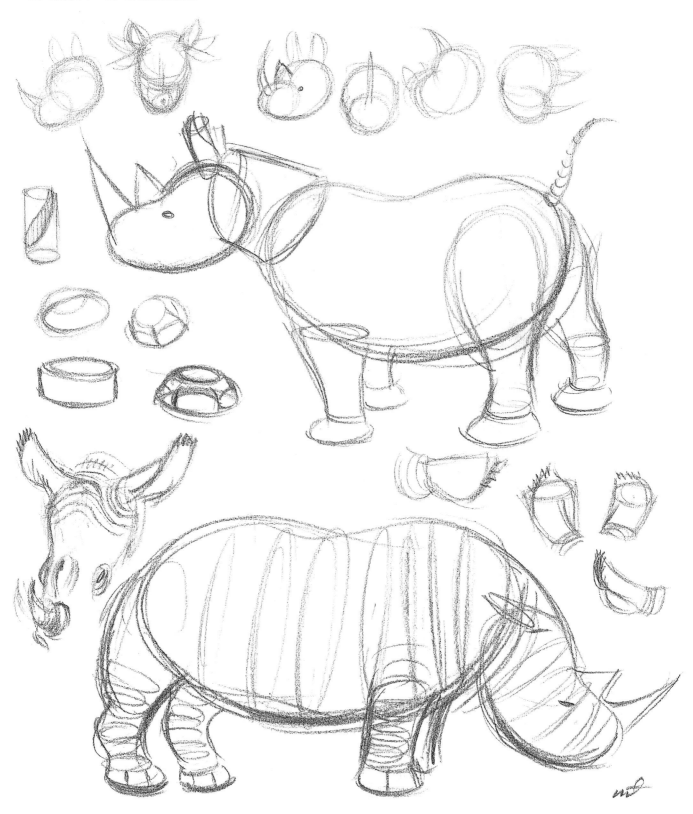

RHINO FOUNDATION

Here are some drawings of black rhinos developed from my own photographs and some fine video information. You can learn a good deal about drawing by copying the work on these two pages.

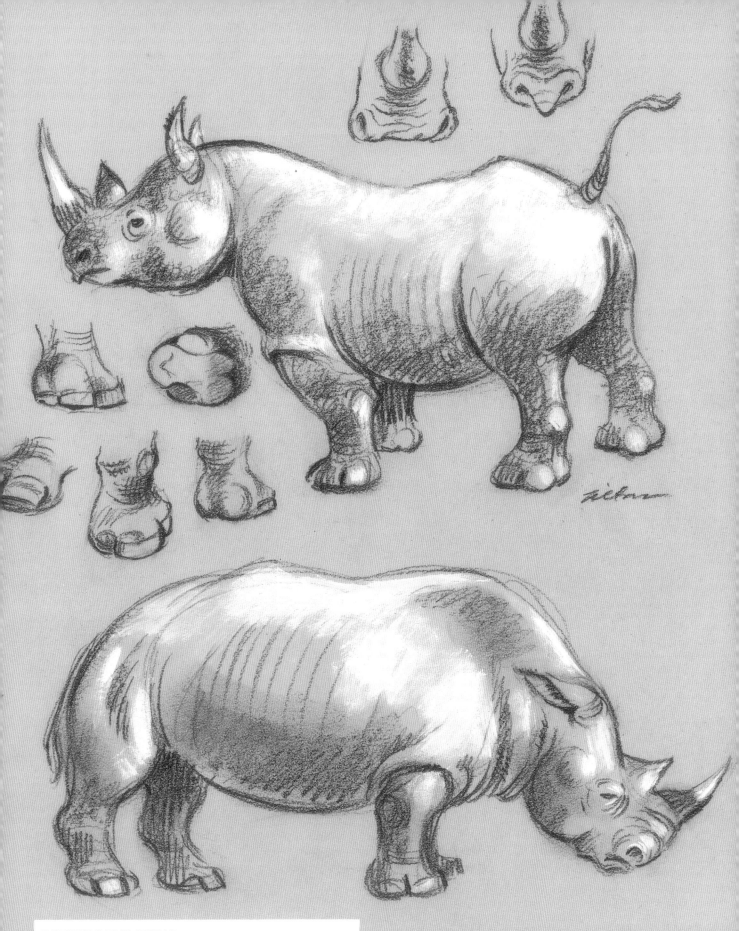

REFINING THE RHINO
This page is simply done with a sketch and wash pencil and thinned, white acrylic on tan, smooth-finish pastel paper.

Draw a Warthog

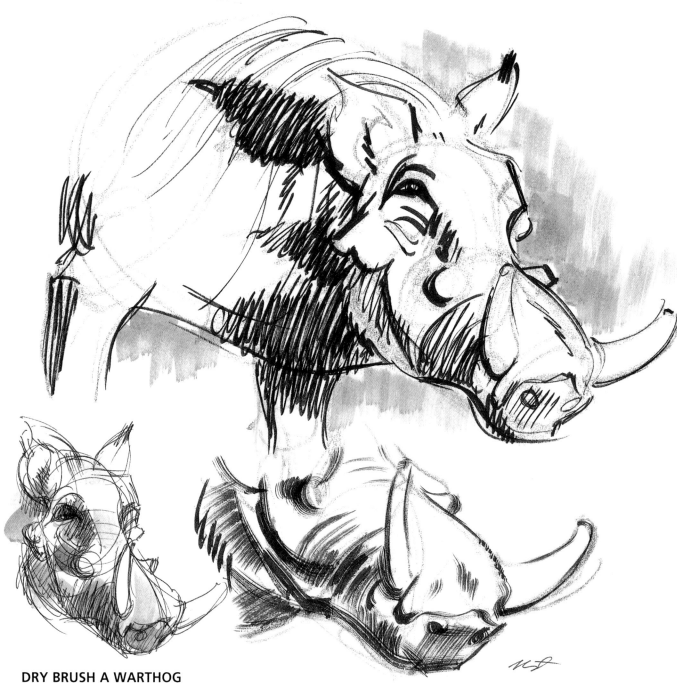

DRY BRUSH A WARTHOG

For variety, I did these three sketches of a typical African warthog, based on my own photographs taken while living in West Africa. The top drawing was done with a marker pen and diluted ink wash. The lower left sketch is a waterproof ballpoint pen and watercolor sketch. The drawing on the lower right was done with dry brush and ink. To do the dry brush drawing, hold your size 5 or 6 round watercolor brush in one hand and a piece of cloth in the other. (Old 100 percent cotton sheets torn into squares make perfect paint rags.) Dip the brush into ink or thinned paint, flatten the wet brush hairs onto the cloth held between your fingers, then stroke the semi-dry brush across the surface or paper. With a little practice this stroke's usefulness will become self-evident.

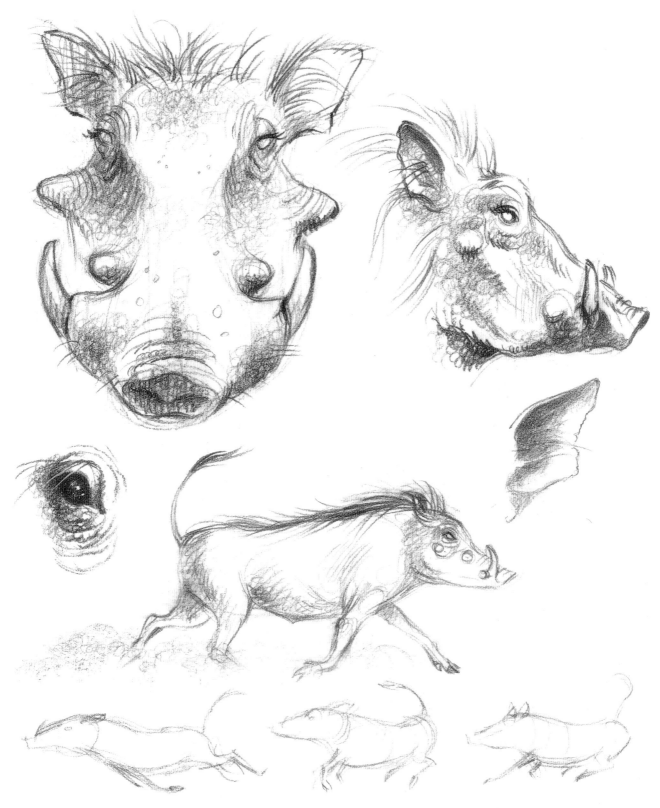

"SQUIGGLE" A WARTHOG

Here is an easy-to-learn drawing method that produces fine results. I'm not sure it has a name, but "squiggles" comes to mind. When you want to show gradations from light to dark, simply hold your pencil as you would for normal handwriting with your weight on the side of your hand, then prescribe a series of very small circular motions, primarily with finger movements. Study my pencil drawings of the warthog and copy them precisely. This method gives you great control and interesting textures.

Draw a Lion

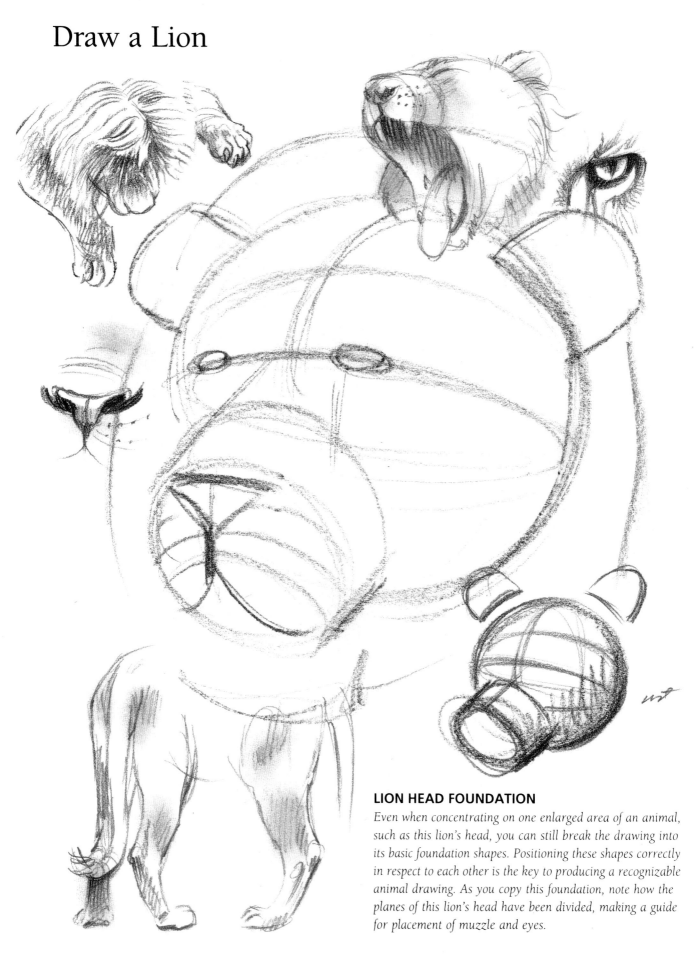

LION HEAD FOUNDATION

Even when concentrating on one enlarged area of an animal, such as this lion's head, you can still break the drawing into its basic foundation shapes. Positioning these shapes correctly in respect to each other is the key to producing a recognizable animal drawing. As you copy this foundation, note how the planes of this lion's head have been divided, making a guide for placement of muzzle and eyes.

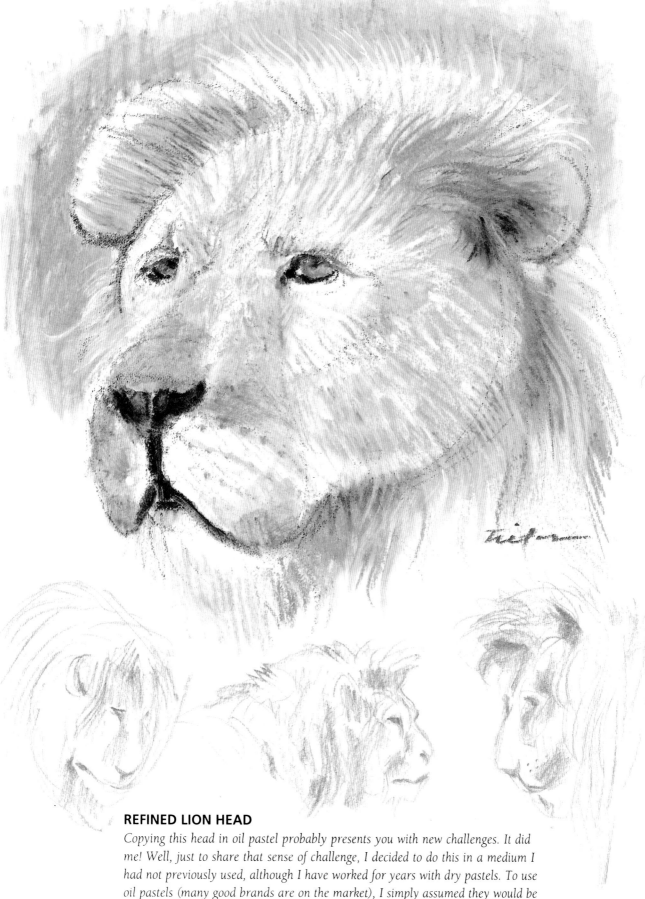

REFINED LION HEAD

Copying this head in oil pastel probably presents you with new challenges. It did me! Well, just to share that sense of challenge, I decided to do this in a medium I had not previously used, although I have worked for years with dry pastels. To use oil pastels (many good brands are on the market), I simply assumed they would be like crayons, a medium most of us have used since kindergarten, and they worked fine. Mineral spirits, a good solvent for crayons and oil pastels, let me blend colors easily using a filbert-shaped, bristle oil brush. Try this method and surprise yourself.

Draw a Giraffe

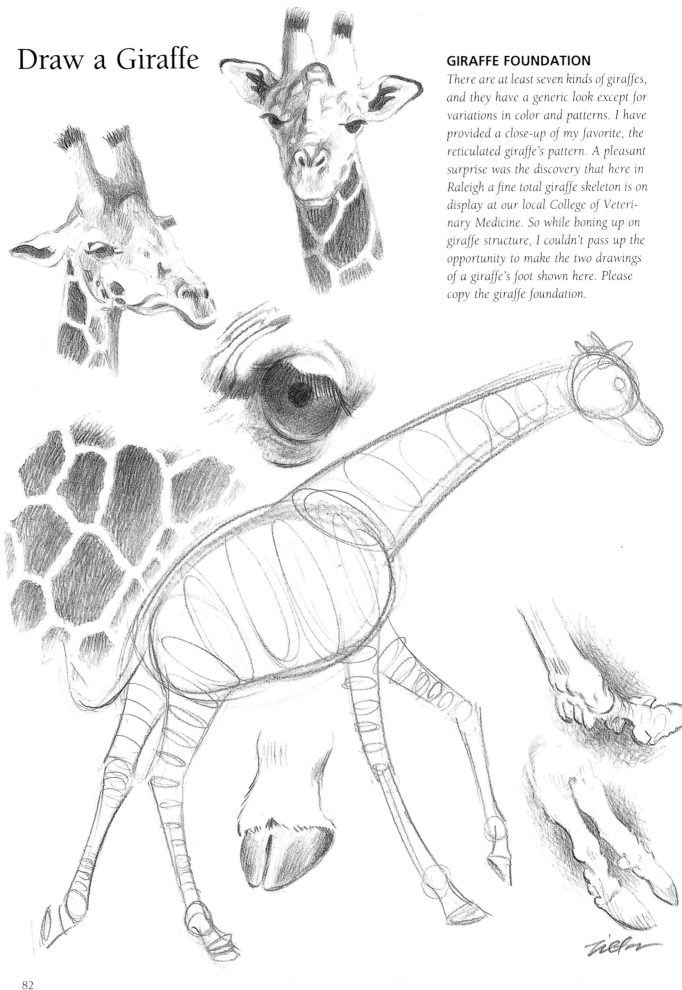

There are at least seven kinds of giraffes, and they have a generic look except for variations in color and patterns. I have provided a close-up of my favorite, the reticulated giraffe's pattern. A pleasant surprise was the discovery that here in Raleigh a fine total giraffe skeleton is on display at our local College of Veterinary Medicine. So while boning up on giraffe structure, I couldn't pass up the opportunity to make the two drawings of a giraffe's foot shown here. Please copy the giraffe foundation.

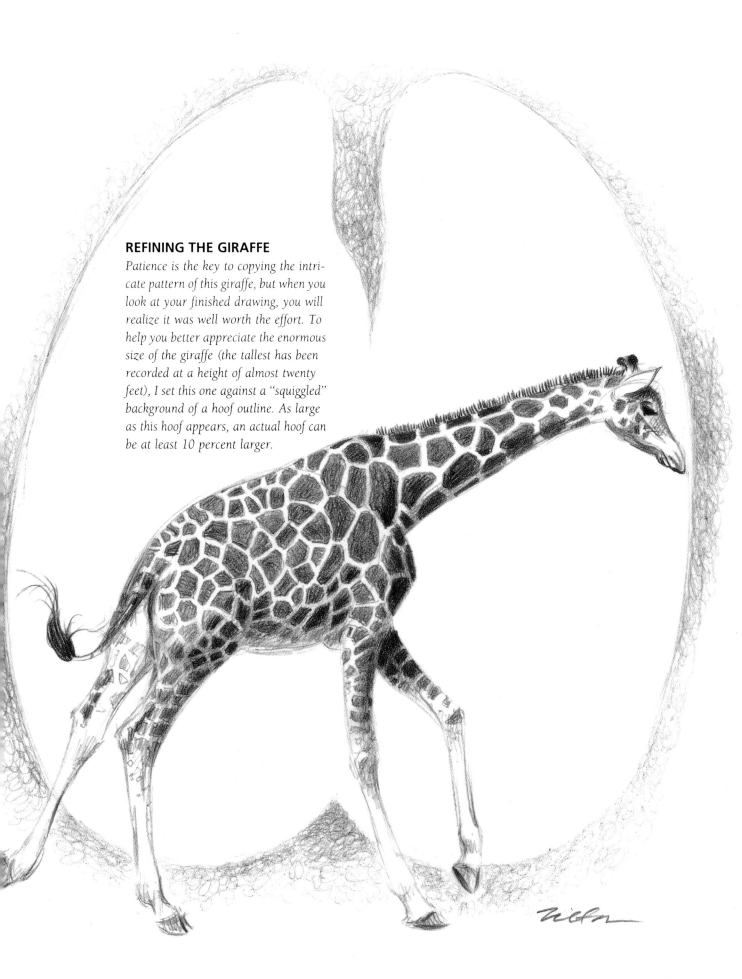

REFINING THE GIRAFFE

Patience is the key to copying the intricate pattern of this giraffe, but when you look at your finished drawing, you will realize it was well worth the effort. To help you better appreciate the enormous size of the giraffe (the tallest has been recorded at a height of almost twenty feet), I set this one against a "squiggled" background of a hoof outline. As large as this hoof appears, an actual hoof can be at least 10 percent larger.

Draw a Buffalo

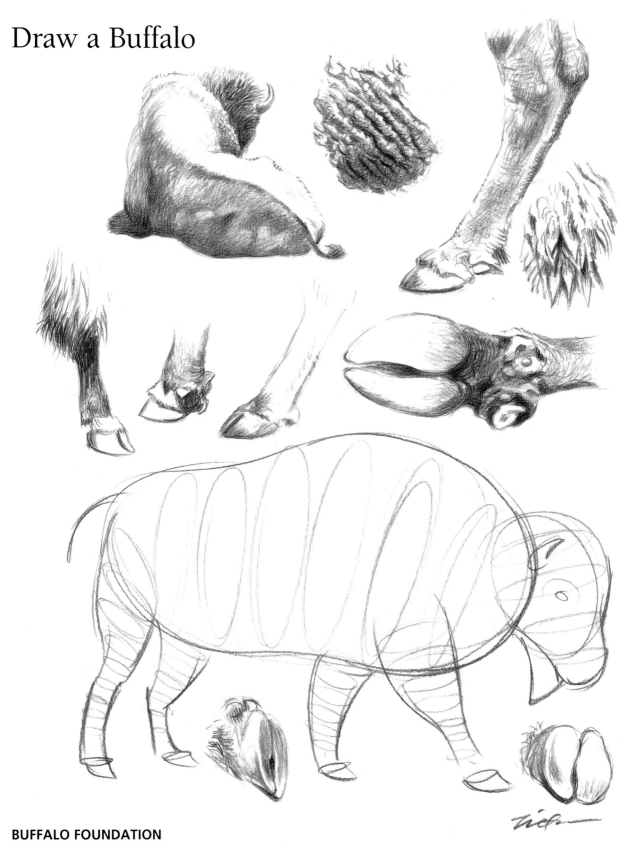

BUFFALO FOUNDATION

The American buffalo is a long-time favorite of mine, in part because I was born in Wyoming, and Yellowstone Park is such a great place if the tourists don't wear you out. These drawings are based on my own sketches and photographs, the results of several visits to this must-see wonderland. In the upper middle I show a typical mass of the buffalo shoulder and neck. Copy this peanut-shaped foundation.

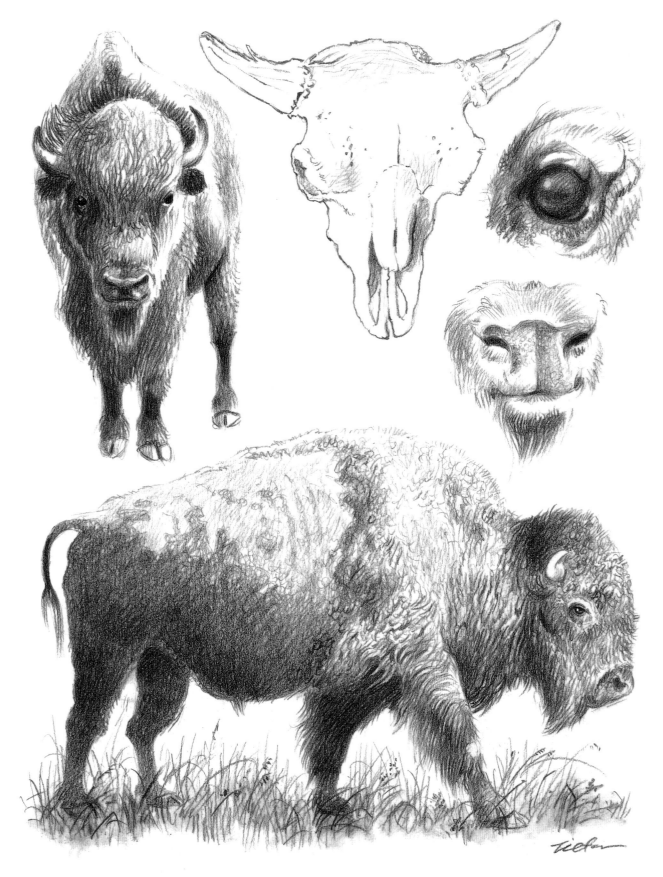

REFINING THE BUFFALO

As you draw this buffalo, look carefully at the different textures of this animal's shaggy coat on different parts of the body, adjusting your pencil marks to match. "Squiggling" works well for the short, curly hair textures, while a combination of lots and lots of tiny curved and straight strokes describes the long, shaggy fur.

Draw a Heron

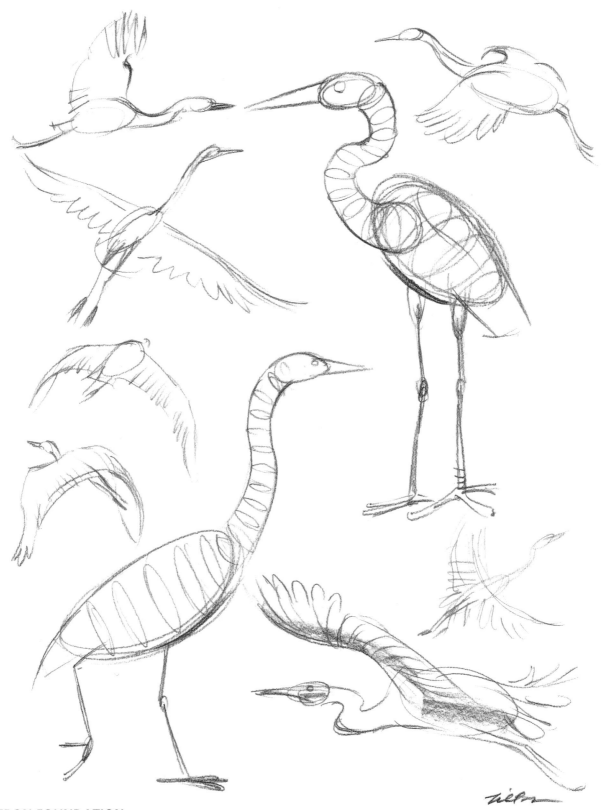

HERON FOUNDATION

Two better-known members of the heron family are shown here, the great egret and the great blue heron. They are actually easy to draw with their football-shaped bodies and long columnar necks.

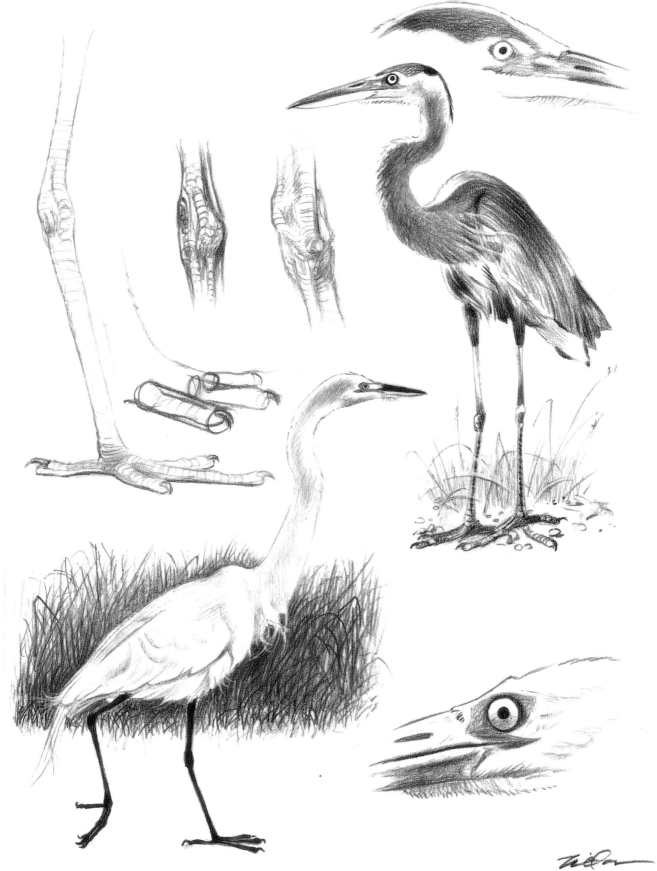

REFINING THE HERON

Once you have established the masses that make these birds distinctive, study their plumage carefully and try to limit yourself to the minimum that establishes each bird's distinct look. Keep your feathering as simple as you can—highlighting a few select shafts and vanes conveys the idea of feathers.

Draw a Deer

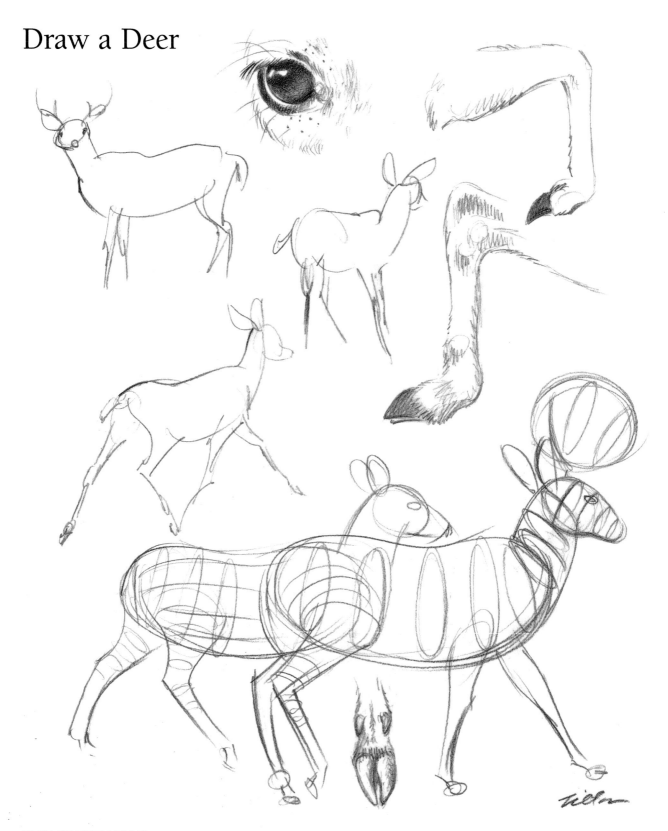

DEER FOUNDATION

We see so many drawings of our handsome white-tailed deer that I decided to show instead the kind I grew up with in Wyoming and Colorado, the mule deer, so named because of its large ears. Particularly note this easy way to draw antlers. Think of the antler rack as a cantaloupe-like globe, and using that structure, you'll see how to draw this seemingly complex feature.

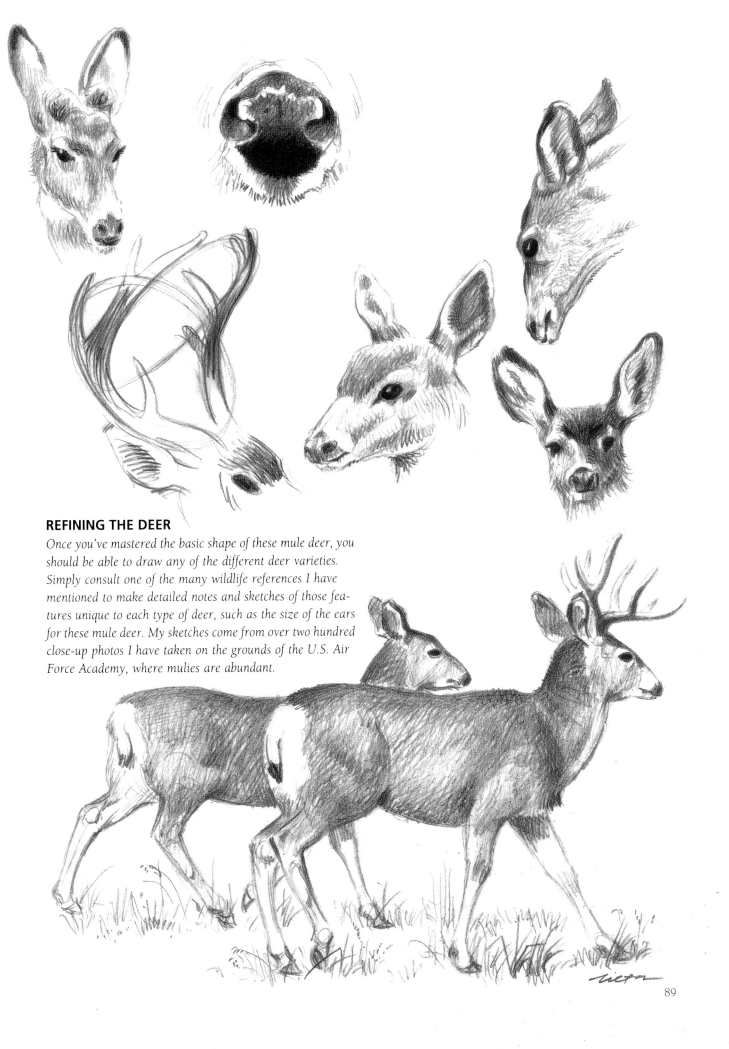

REFINING THE DEER

Once you've mastered the basic shape of these mule deer, you should be able to draw any of the different deer varieties. Simply consult one of the many wildlife references I have mentioned to make detailed notes and sketches of those features unique to each type of deer, such as the size of the ears for these mule deer. My sketches come from over two hundred close-up photos I have taken on the grounds of the U.S. Air Force Academy, where mulies are abundant.

Draw a Goat

GOAT FOUNDATION

Goats do have a generic look, meaning one goat looks very much like another, and that's generally true of animals, but with careful observation one can detect and depict individual shapes, relationship of masses and often enough, distinctive personalities. Be careful though when observing such subjects—Ivory, the goat shown here, ate part of my shirt and pant's cuffs while I was busy observing other details!

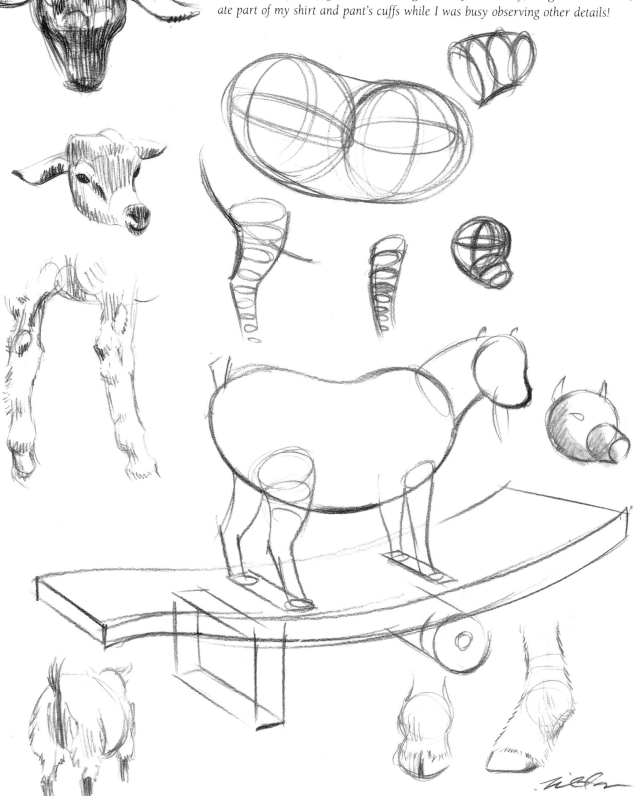

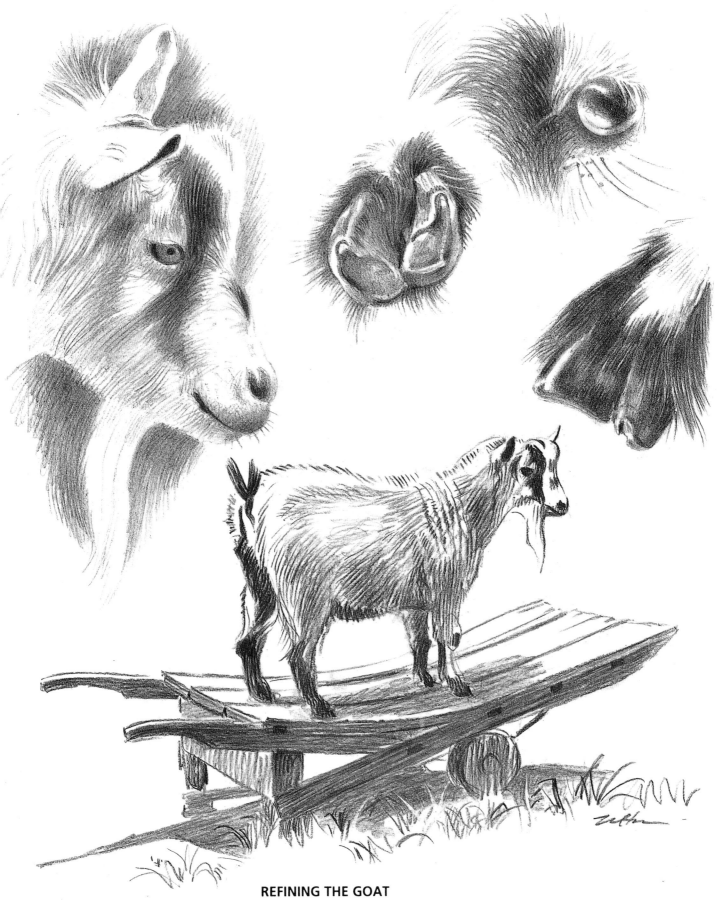

REFINING THE GOAT

After copying the foundation drawing on the left, add the details as I've shown. The antique wheelbarrow Ivory stands on is at our local Farmer's Market. Why not try to reproduce it too?

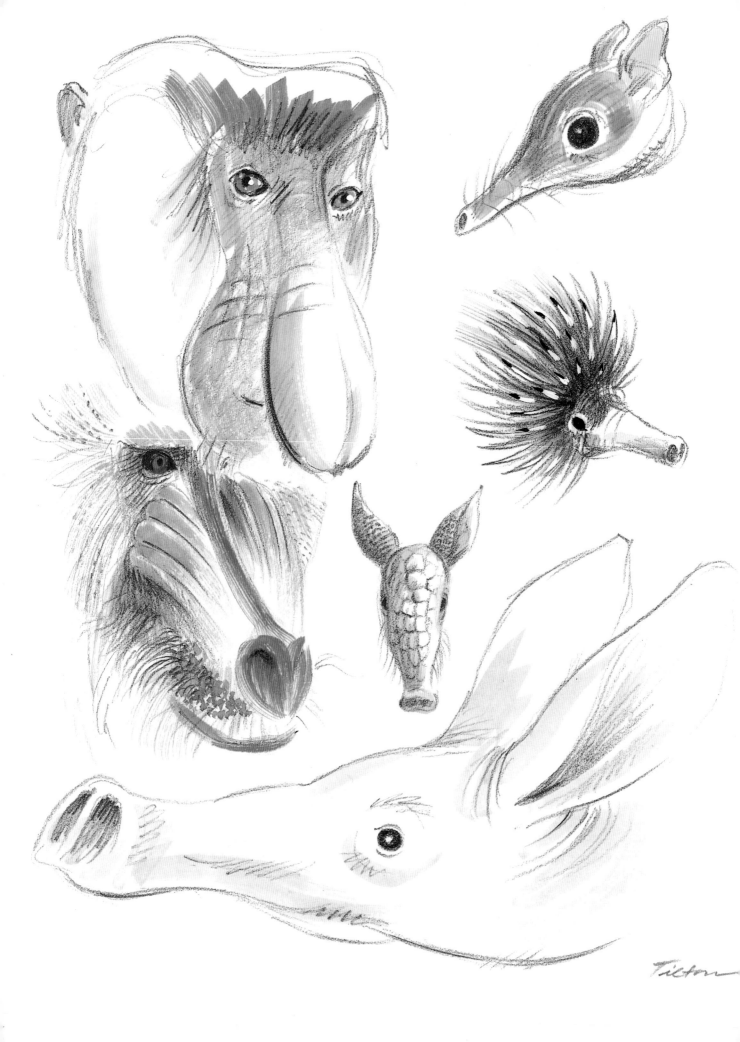

MAKING YOUR DRAWINGS ACCURATE

Throughout this book and in my articles, workshops and demonstrations I stress the critical importance of observation and visualization. Careful observation assures you are correctly seeing, then recording, the differences between animals. Consider the small differences in animals such as a leopard and jaguar, a white-tailed and mule deer, an Indian and African elephant, or among the different types of zebras. Being aware of the often subtle differences will help you take advantage of similarities.

Most of us are familiar with an elephant's trunk, but there are hundreds of other noses in the animal world that are just as unique and different. Consider, for instance, the wide variety in shape and size of animal noses such as those I show on the left: a North African elephant shrew, New Guinea's spiny anteater, Borneo's proboscis monkey, an armadillo, an aardvark and a mandrill—to name a few that probably aren't nosing around your flower beds. These drawings are straightforward pencil drawings over which I have added some minimum brush strokes of watercolor. Copy them and add them to your ever-growing portfolio.

Similarities and Differences

My oil painting of the donkey, zebra and horse on page 96 demonstrates how useful it is to be aware of what features animals have in common, and also how important it is to be aware of those features that differ among similar animals.

For instance, if I only had a horse as a model along with some detailed facts about the zebra and/or donkey, the latter two would be fairly easy to do. If I had only an actual donkey and just some reference material about a zebra and a horse I could do a pretty good example of all three, and so on. This is because they all have a similar basic foundation. It isn't surprising that budding artists might be a bit uneasy with the thought of drawing a zebra, when those same aspiring artists might be fairly familiar with a horse or donkey. They simply have failed to see that a zebra has much in common with both of those more familiar animals. A tabby cat and a mountain lion have much in common, as do big dog breeds and wolves, and so forth.

By the same token, the small differences in shape, mass and detail help us distinguish a donkey from a horse, a dog from a wolf, and so on.

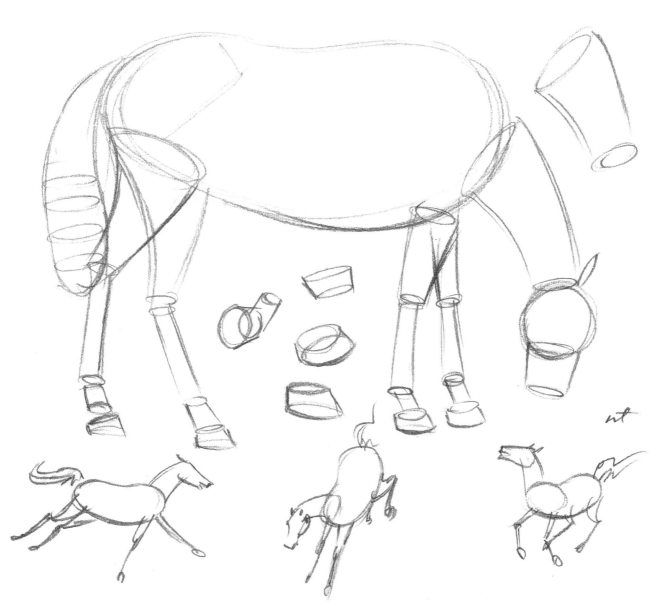

Although this foundation drawing is actually a horse, with a little alteration you could use this same structure as a basis for drawing a pony, a donkey or a zebra. Many animals share such common characteristics.

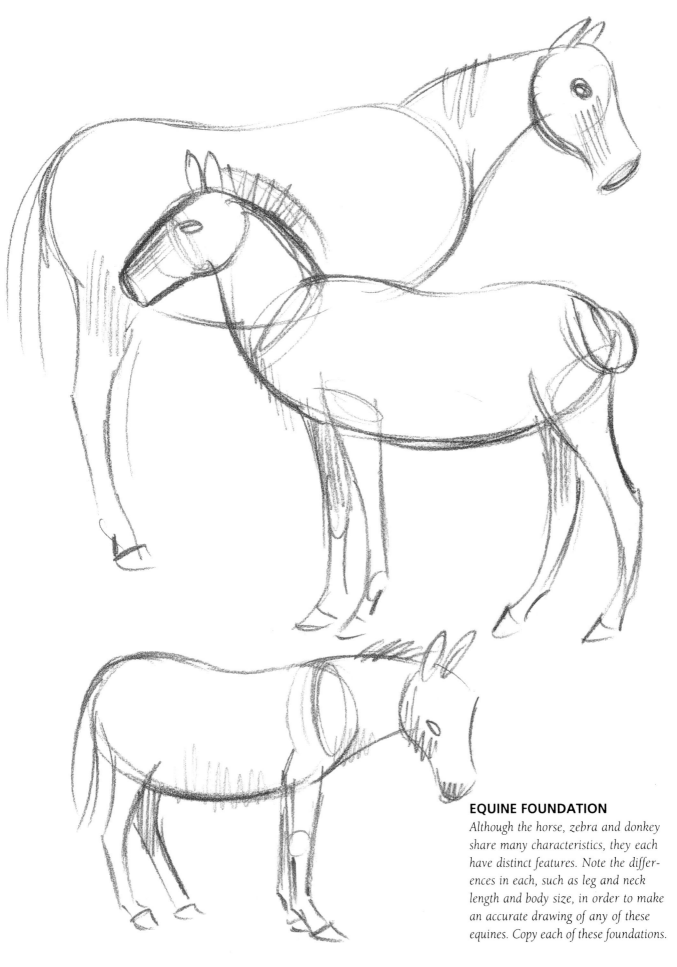

EQUINE FOUNDATION

Although the horse, zebra and donkey share many characteristics, they each have distinct features. Note the differences in each, such as leg and neck length and body size, in order to make an accurate drawing of any of these equines. Copy each of these foundations.

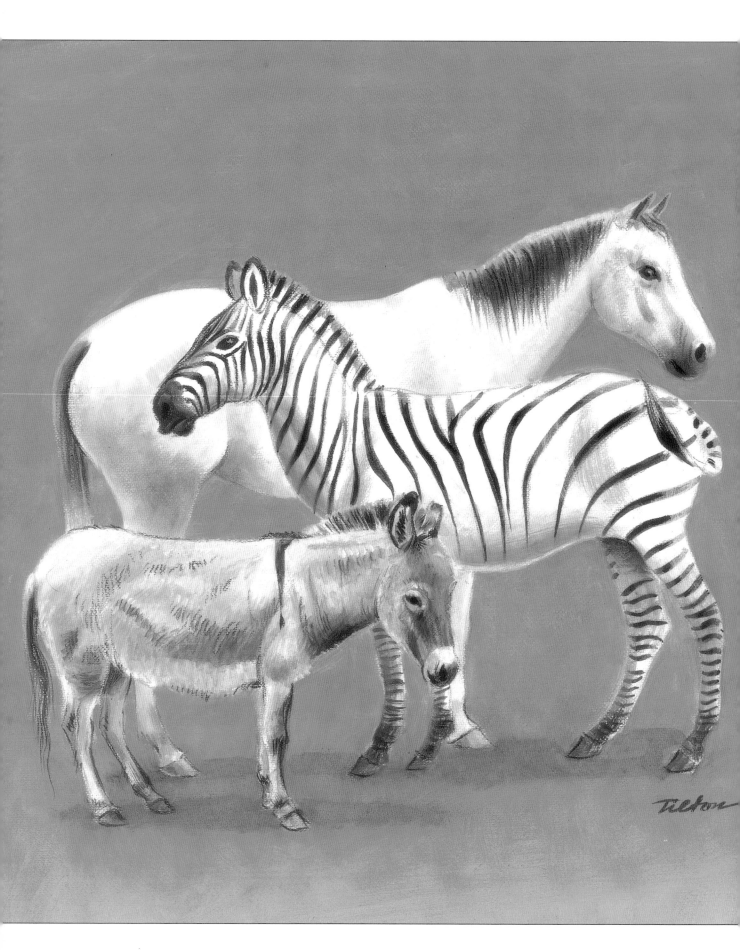

◄ REFINING THE EQUINES

For this painting I used a sheet of finely textured Acryla-Weave, a synthetic product made for acrylic but one I like for small oils too. Acryla-Weave has a fine gesso priming, to which I added two more coats of Golden gesso, allowing them to dry before beginning. (I added gesso because Acryla-Weave is made for acrylic painting, and I wanted to ensure my mineral spirit solvent would not leach through.) With a soft carbon pencil, I drew the three animals directly on the Acryla-Weave surface, misted it with fixative, then proceeded to broadly paint the entire piece with Golden acrylics. When the background dried, I made my finished painting over it using a very simple palette of M. Graham's excellent oil colors, thinned as needed with good-quality mineral spirits. Note: I paint with several thin layers, allowing each to dry thoroughly, overnight at most, before adding another.

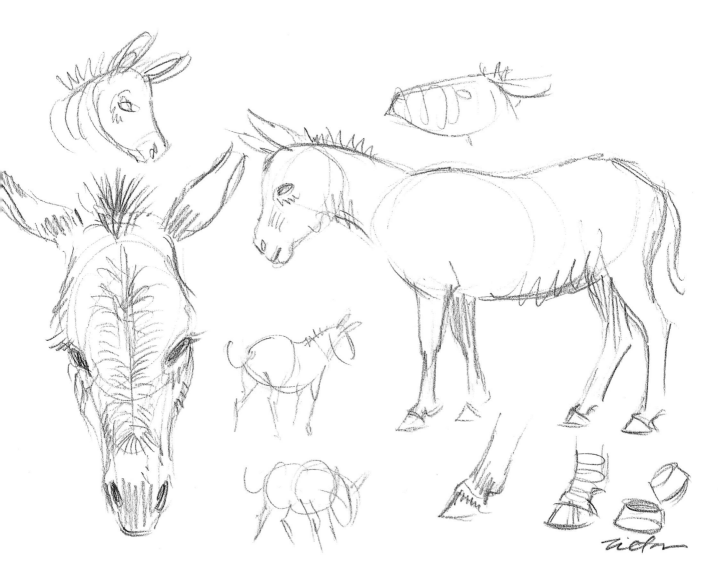

Copy and compare these sketches of a donkey with the horse foundation on page 94. Train yourself to always be on the lookout for the unique traits that make each animal different.

Draw a Foal

FOAL FOUNDATION

Not only must you be aware of the differences from one species or breed of animal to another, but also the differences between adult animals and their young. As you copy these foundation drawings, note the proportional relationship of the body and legs compared to the horse you did previously.

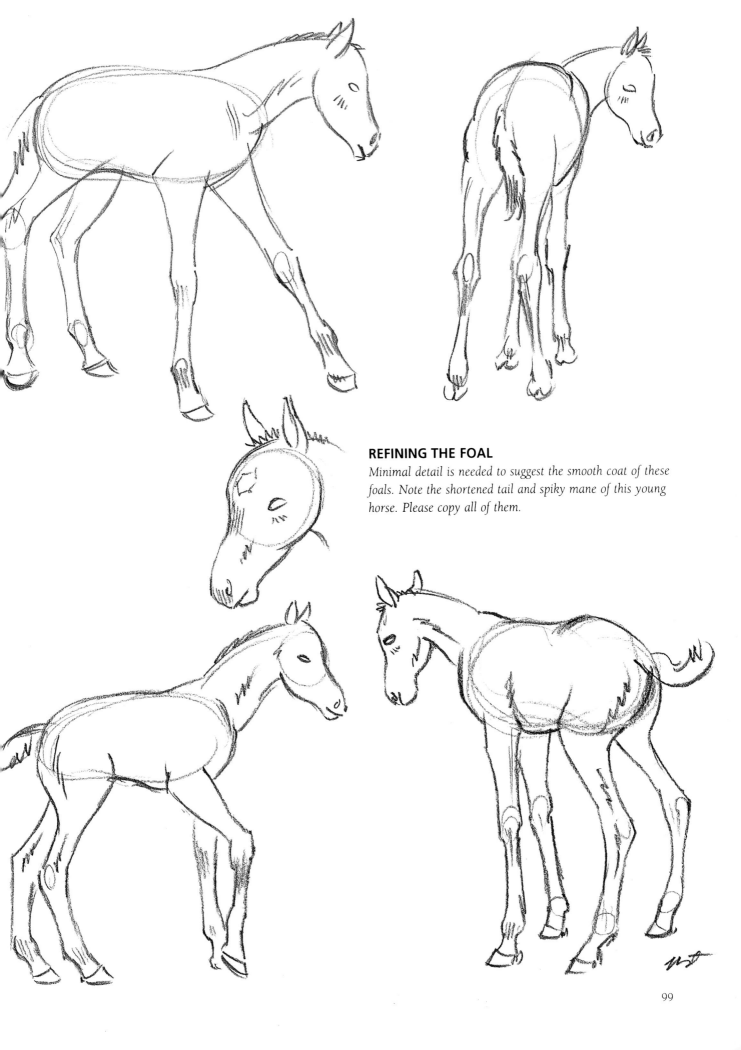

REFINING THE FOAL

Minimal detail is needed to suggest the smooth coat of these foals. Note the shortened tail and spiky mane of this young horse. Please copy all of them.

The Foal in Color

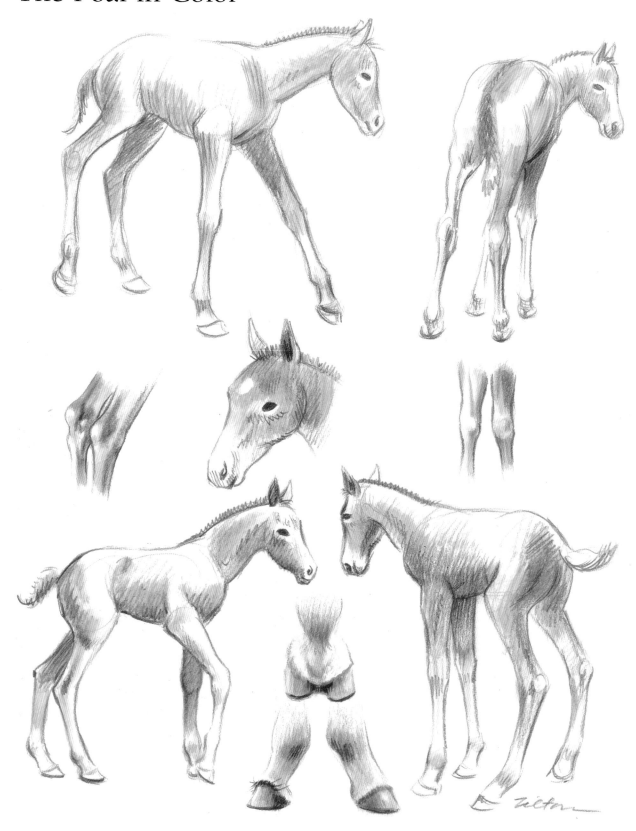

Here I have finished the foal drawings with touches of Conté pencils. Notice how I allowed the white of the paper to represent the highlights on the foal's coat. Now you try it.

The Horse in Color

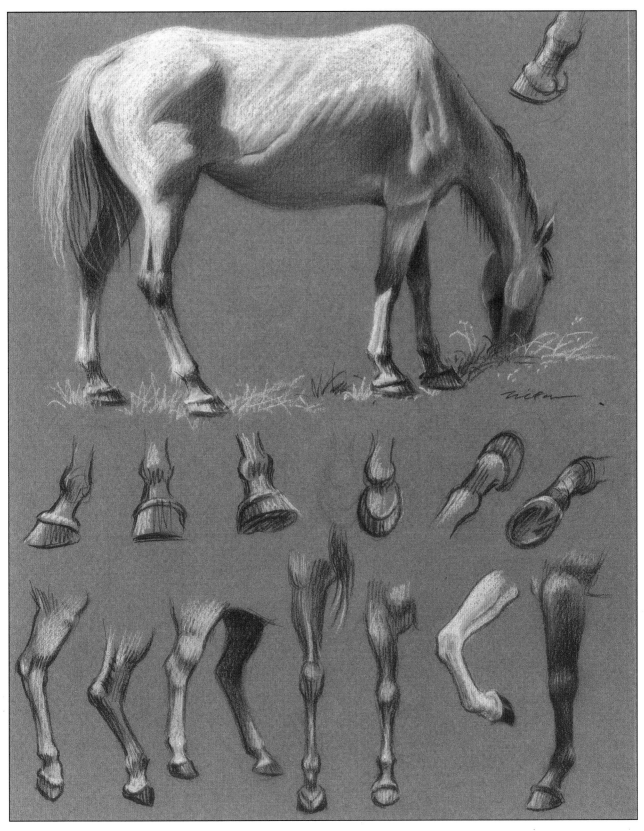

Using the foundation sketch you copied from page 94, complete this horse drawing. Here I have used General's black-and-white charcoal pencils on gray Canson paper.

More on Accurate Details

Just like the equine family, members of the monkey family have much in common, yet each species has uniquely different features, and their relative sizes vary as well. As an interesting example, consider the impressive range of ear sizes—from the relatively small ones of the large gorilla to the large ones on a typical, much smaller chimpanzee. Please copy the following drawings of the gorilla and chimpanzee.

The first animal drawing or painting I recall selling was of Gargantua the gorilla, in his time the most famous animal in the world. Gargantua was owned by the Ringling Brothers Circus. My client was John Ringling North, the owner, and I was a teenage student at Ringling School of Art. The school is in Sarasota, Florida, the winter quarters of the circus. I spent much of my free time there drawing and painting circus animals and people, gorillas being my all-time favorite because of their massive, simple forms and incredible strength.

Gargantua, acid thrown in his face as a youngster and features altered by plastic surgery to look demonic, deserves a book by himself. I never found him frightening, but his life was too often a sad commentary on abuse of an animal by vicious and exploitive humans. He was truly a powerhouse. Fully grown, Gargantua weighed 550 pounds and his arms had a nine-foot span.

I find it interesting to record unique features and details in my sketchbooks, such as those I have just related to you about Gargantua. As an example, throughout this book I have included small vignettes of such things as eyes, ears, nose, feet and so forth. I strongly recommend you get in the habit of doing this yourself. Later, when working on a drawing or painting of your own, you will find that extra effort can pay off. Your own reference is unbeatable when last-minute questions develop such as "What did those nostrils look like?" and "Was that a smooth hoof or was it cloven?" and so on.

Besides being enormously helpful, recording animal features provides your notebook with a change of pace. Also, correctly recorded information helps broaden your knowledge and awareness of the intricate, miraculous vastness of our planet's animal world. Sadly, some of your sketches may well be records of certain species destined for early extinction, and that alone should be ample motivation.

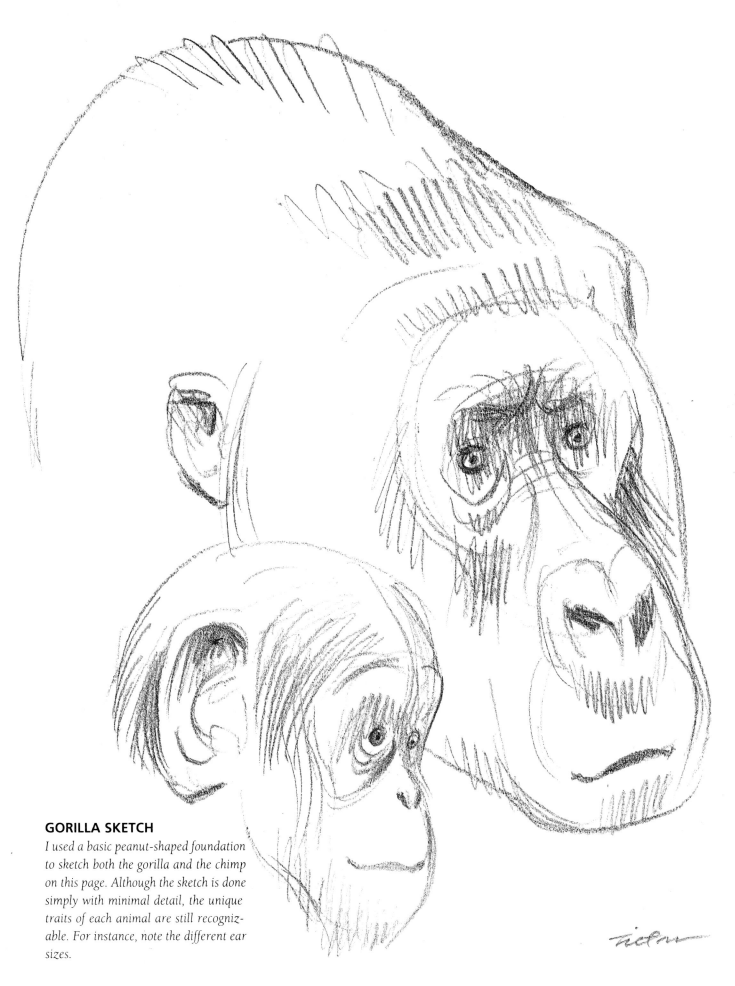

GORILLA SKETCH

I used a basic peanut-shaped foundation to sketch both the gorilla and the chimp on this page. Although the sketch is done simply with minimal detail, the unique traits of each animal are still recognizable. For instance, note the different ear sizes.

Draw a Lamb

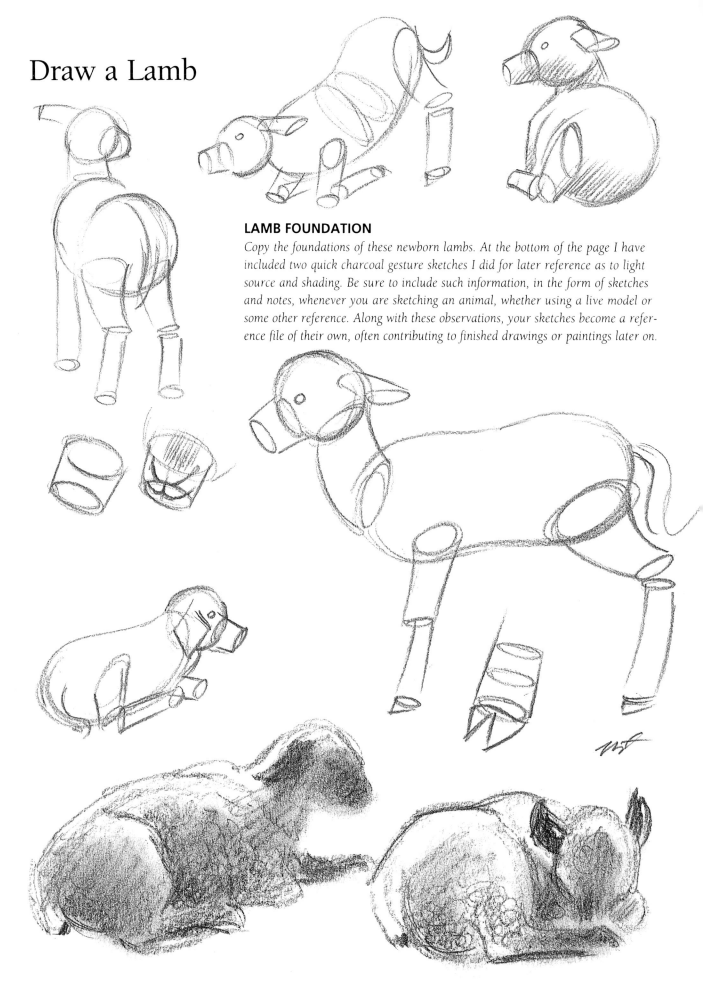

LAMB FOUNDATION

Copy the foundations of these newborn lambs. At the bottom of the page I have included two quick charcoal gesture sketches I did for later reference as to light source and shading. Be sure to include such information, in the form of sketches and notes, whenever you are sketching an animal, whether using a live model or some other reference. Along with these observations, your sketches become a reference file of their own, often contributing to finished drawings or paintings later on.

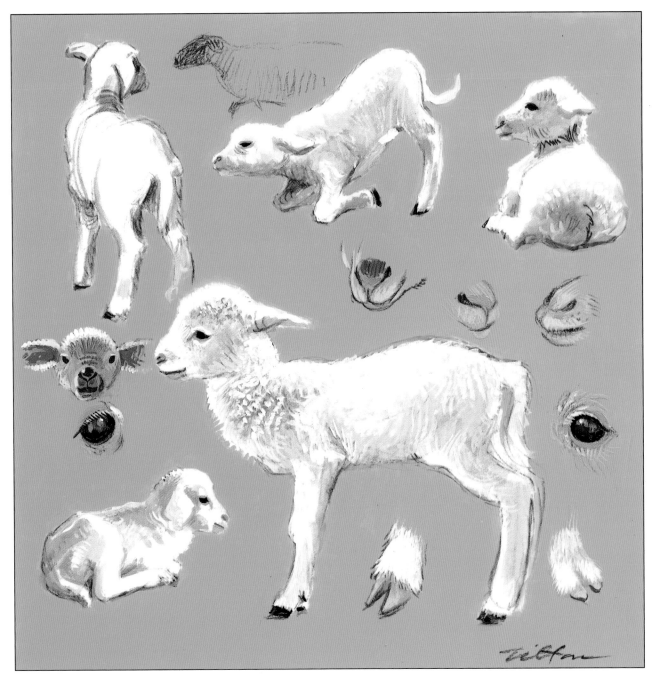

LAMB IN ACRYLIC

I have refined these lambs using acrylic paint, following the same steps I mentioned for the finished equine painting. Note how the different types of brushmarks suggest the different textures of the lamb's wool. Try this yourself and be pleasantly surprised.

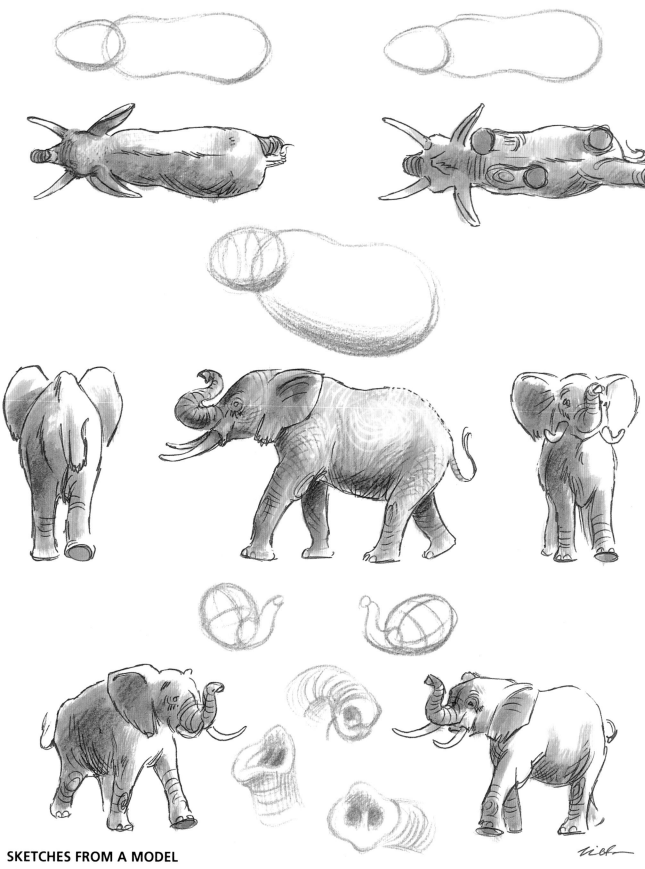

SKETCHES FROM A MODEL

This page shows drawings of an African elephant in multiple views. I made this page from a simple but accurate small model I bought. For accuracy, note this is an African elephant, with its two-fingered nose tip. The drawing was made with watercolor pencils and a ballpoint ink pen.

Chapter Five

CREATING YOUR OWN REFERENCE MATERIALS

An impressive range of information is available about almost any animal anywhere; one only needs to learn to look. One way to assure you have the right information when you need it is to create and maintain your own files. Now is your best time to start! Reference files need not be complicated; a sturdy box and regular file folders will do nicely. Later, as your interest increases and more material comes your way, you can expand your system.

I still have useful files on horses, dogs and cats that I began in the early 1950s. As my interests expanded, my needs grew and I divided my reference material into families, such as: canine for dogs, feline for cats, equine for horses, bovine for cows, and so forth. Expansion of these files allowed me to subdivide again, and the bovine file, for example, split into steers, bulls, oxen, water buffalo and other split-hoofed animals. The single temporary file box is now a large, four-drawer, legal file cabinet. And it is filled; Murphy's Law in action! Some professional artist friends have six filled file cabinets, so you're only limited by your time, enthusiasm and space.

Sketches on File

When you finish working through this book you will find it valuable to begin filing your photo prints and/or slides. Taking your own photographs requires that you be at the source, a most rewarding aspect of doing animal art. I find that 4″×6″ photo prints are the minimum useful size. That size fits easily into a standard shoe box. If you use inexpensive 5″×7″ file cards as separators you have an excellent, low-cost, easy-to-use system for filing your photo references. And don't forget your negatives! Ideally they should also be filed and reasonably accessible. On their plastic protective sleeve, identify them with a fine-tip, permanent marker or a fine-point gold or silver marker.

As you progress, save your work because it is the best measure of your progress. Then too, predictably, there will be times when you get discouraged, even depressed about what seems a lack of progress. That's normal and to be expected from time to time. That is when it is most productive to haul out past samples of your work and see objectively how much real progress you have made. You will be pleasantly surprised!

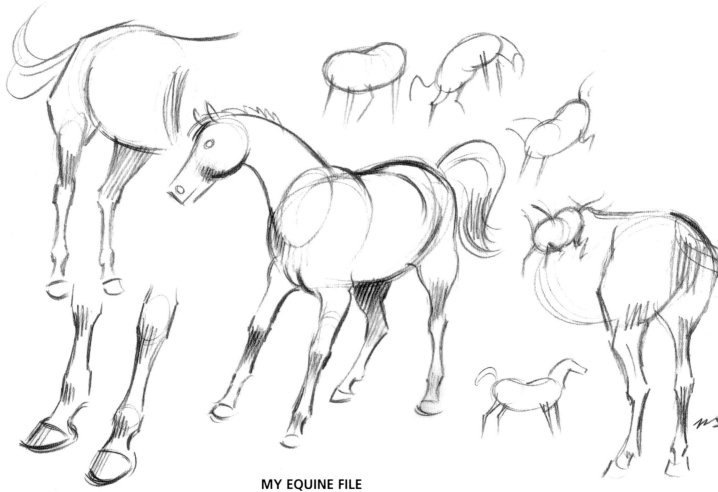

MY EQUINE FILE

This sketch comes from one of my many reference files. To begin with, you may only have a few categories, but as you collect more and more information, you can break large files into subfiles, such as an equine file with separate sections for horses, donkeys, etc.

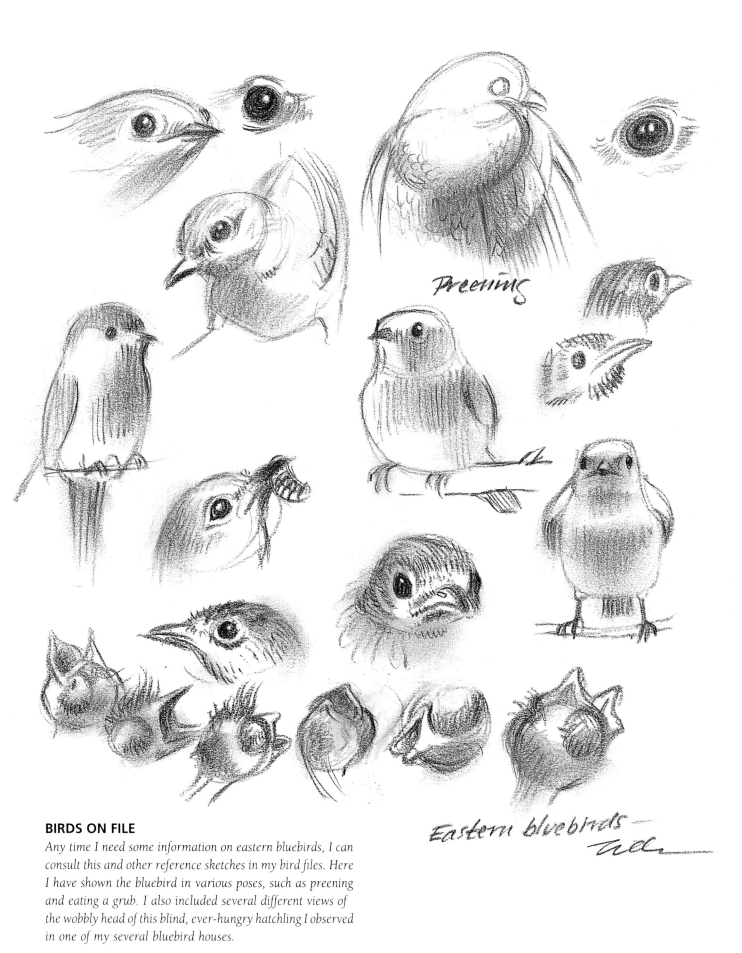

Preening

Eastern bluebirds

BIRDS ON FILE

Any time I need some information on eastern bluebirds, I can consult this and other reference sketches in my bird files. Here I have shown the bluebird in various poses, such as preening and eating a grub. I also included several different views of the wobbly head of this blind, ever-hungry hatchling I observed in one of my several bluebird houses.

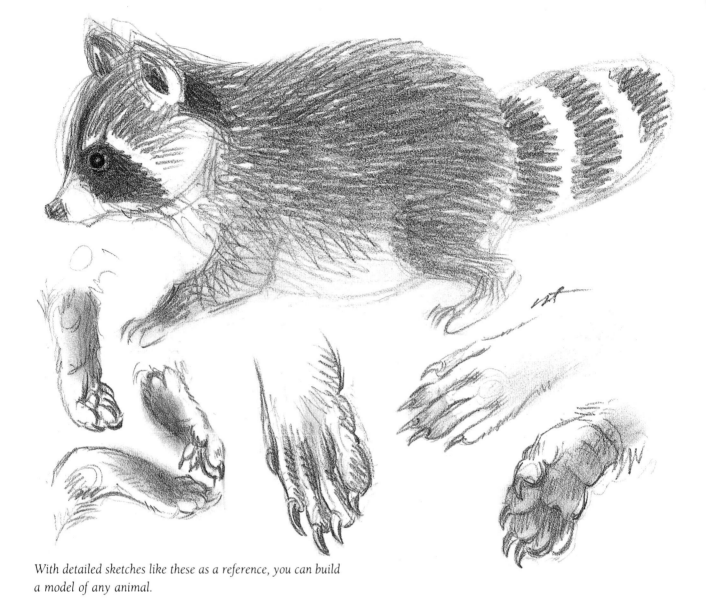

With detailed sketches like these as a reference, you can build a model of any animal.

Basic Sculpture

Working from small sculptured models of animals and birds is a superb way to improve your knowledge of whatever species is to be portrayed. Miniature models will often help you determine the best, most effective lighting for your drawings and paintings. However, the model you need may not always be available, so this section deals with ways of making your own convenient, reliable and inexpensive models. Making animal models to draw or paint from is remarkably easy, and creating your own gives you a much better understanding of the distinctive shapes and masses of individual animals as well as the way their parts fit together.

That suggests a fine two-for-one idea. First, copy the pages of raccoon drawings, then, that done, use your drawings as a model for your first try at sculpture.

Here's the procedure. The first step is to assemble working materials and enough dependable reference materials to provide good visual information about the overall shape of the animal—in this instance, a raccoon—you plan to model. Regular art store modeling clay is excellent for the project. The few tools you need are available at most art, craft and hardware stores. The simple, inexpensive modeling tool I recommend is most often found in a well-stocked art store

or one of the larger craft stores. Note: I get used dental tools from my dentist and buy small modeling tools at favored art or hobby shops.

You need both a small pair of long-nosed pliers to manipulate wire and a pair of wire-cutting pliers to sever the soft aluminum wire of the heaviest gauge you can bend easily. You also need some reliable instant glue, the best source being a hobby shop. The wire and glue are for making an armature, a traditional skeletal framework structure to hold your clay in place for sculpting.

Remember earlier when I had you draw and redraw gestural sketches of animals? Essentially that's what you

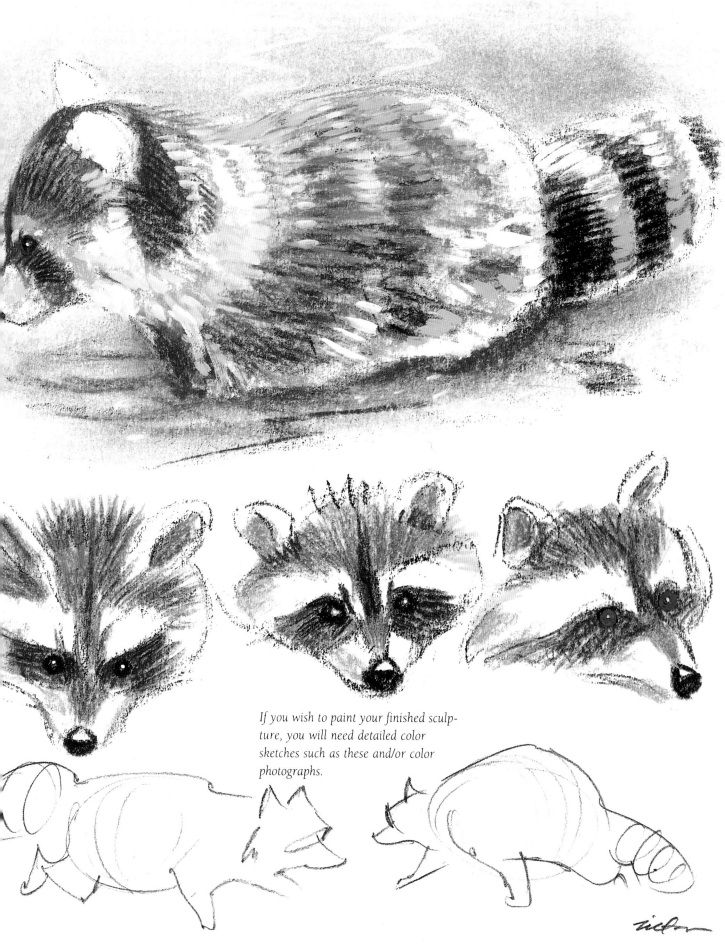

If you wish to paint your finished sculpture, you will need detailed color sketches such as these and/or color photographs.

will do with the wire—bending and forming segments of the soft wire to create the equivalent of a "stick" animal figure with the essence of the selected animal's shape. Wherever there is a joining of wire, add a few drops of instant glue and let the joint dry. For those who like to speed up the process, spray on a bit of accelerator, a liquid found in most hobby shops that immediately cures instant glue joints. Note: To fix the wire joints together I use two-part, quick-cure epoxy putty obtained from a hobby shop.

When the armature is dry and formed in the desired pose, start pressing small pieces of clay on it, melding each piece to another. Continue doing this until your sculpture takes acceptable shape. After that, continue shaping the figure, using a modeling tool and your fingers, adding clay and smoothing it until the model has an adequate look. Now you have created the very kind of foundation I mentioned in detail earlier.

Refining what you have created is now a matter of patience and experimental self-discovery. By refining I mean adding such features as hair, feathers, scales, finely detailed eyes, noses and so on. Adding these features will most likely call for different tools such as toothpicks, nutpicks, odds and ends of plastic, etc.

If, for example, you are doing a deer and need antlers, form them from wire to approximate the shape of antlers and fix that to the head. Next, simply roll out a length of clay with your index finger and press sections of it against and around the armature for the antlers. Do this also with the legs, tail, etc. If modeling a moose, flatten a piece of clay in the shape of its large antlers, then apply them to a wire framework constructed as described for the deer.

Your model is now adequate for sketching, for drawing masses in relation to each other, assuming any realistic pose you wish, and for useful determination of lights and shadows. If you wish, by using acrylic or oil paints you can also enjoy painting the animal's colorations on the modeling clay. Oil paint works best although it takes longer to dry. That problem can be overcome by adding a cobalt drier (sold at most art supply stores). I recommend oil because clay's oily surface doesn't readily accept water-base paints. Before you paint your model, make some sort of stand to place it on. A simple, easy-to-make coat hanger stand is the kind I often make.

See my procedural illustration on the following page for how the model develops.

Two other superior modeling materials are the plastic or polymer clay that bakes quickly in your oven and Creative Paperclay that air hardens in reasonable time or oven bakes in thirty minutes. Of the different brands of polymer clay on the market, I prefer Sculpey. With this material, and others like it, you can make anything from simple pieces to gallery-quality sculptures. Nan Roche's fine book, *The New Clay*, published by Flower Valley Press, offers the best information on working with polymer clay, and you can get helpful tips on Paperclay by contacting Creative Paperclay, 1800 S. Robertson Blvd., #907, Los Angeles, CA 90035.

Papier-maché is yet another first-rate material for making your own reference figures. Most libraries have helpful books that describe its use through easy, step-by-step procedures.

There are extensive ranges of ready-made models available in hobby, toy and nature stores. These figures range from simplistic to excellent, accurate sculptures of a range of wild animals.

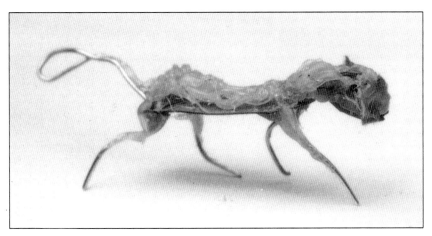

THE SKELATILT ARMATURE

Here is a photo of my finished raccoon armature. The next step is to fill out the shape of the raccoon by molding clay over the wire form.

A New Way to Build an Armature

I have always wanted a better sculpture armature system, so for this book I developed a very simple, original method for you to follow. Pardon the ego, but I'll call it "Skelatilt." In the example I use, I have a raccoon in mind, but it should be easy to visualize that this armature can be adjusted to approximate the shapes and mass of any animal. For example, if your subject is an African elephant, parts B and C would be somewhat egg-shaped.

Once cut in suitable shapes and lengths, you can assemble parts with instant glue, with fastest drying obtained when using a spray "accelera-tor," available at most hobby shops. Fast-drying (four-five minutes) epoxy from hobby and hardware stores works very well too. Even better, the now commonplace hot glue gun does an exceptional job of quick, strong assembly.

I have best results with the Black and Decker cordless glue gun that works with their small gas containers, buying both gun and cylinders at one of their discount outlets. Note in my photograph of an assembled Skelatilt how I have flowed hot glue from the glue gun tip over most of the armature, using the still-warm nozzle and finger pressure to encourage bending of various parts into desired shapes. If I need to do further bending after the hot melt glue has hardened, I use hairdryer heat to further shape and bend parts.

With your Skelatilt complete, the easiest modeling material to cover it with is regular modeling clay, commonly called plasticene, but there are a number of other easy-to-work-with items like rock putty, papier-maché and so on. Most reasonably well-stocked art supply stores carry a number of suitable modeling materials.

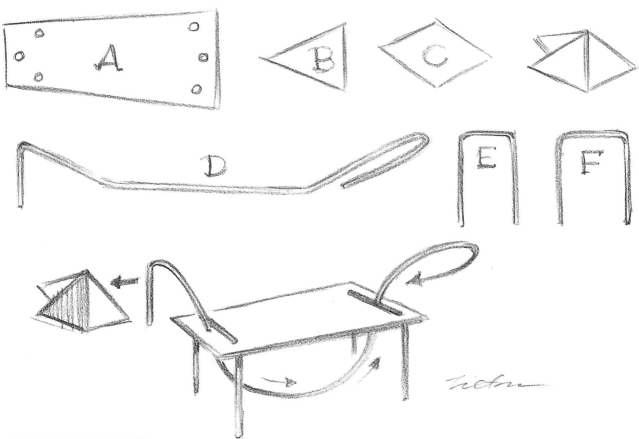

ARMATURE DIAGRAM

A is the general body shape. If you need to add another dimension, see parts B plus C combined. B is the approximate profile of your subject's head reduced to simplest shape. C is the approximate width from ear to ear of your subject's head, greatly simplified. D is soft aluminum wire, or pipe cleaners, etc., shaped on one continuous line from head to end of tail. E and F are wire leg supports.

Final Exam

And now, to wrap it all up, give yourself a confidence-enhancing sort of challenge in the form of a "final exam." You, your family and friends will serve as judges. You are going to draw a zebra!

Now, put all you've learned to use and produce a zebra you can call your own. Start by studying my sequential drawings that show how I constructed drawings from one of Creart's fine zebra figures. These pages of zebra drawings will lead you through the complete procedure of drawing and painting a frame-worthy work of your own.

This is an impressive exercise, because as difficult as it may seem, you will produce a better-than-you-ever-hoped drawing of a multistriped zebra. Begin with a clear plan in mind and keep your plan simple. And there will be lasting rewards. For one, when you have finished with this drawing project, you will be ready to take on any animal anywhere.

This photo of Creart's 13″ × 8″ × 12″ zebra sculpture was provided by Creart's president, Carlos Estevez. I chose Creart's zebra sculpture for your wind-up drawing exercise because at first glance, this animal appears to be beyond the drawing ability of all but the most advanced artists. But you will soon prove that is not so!

Draw a Zebra

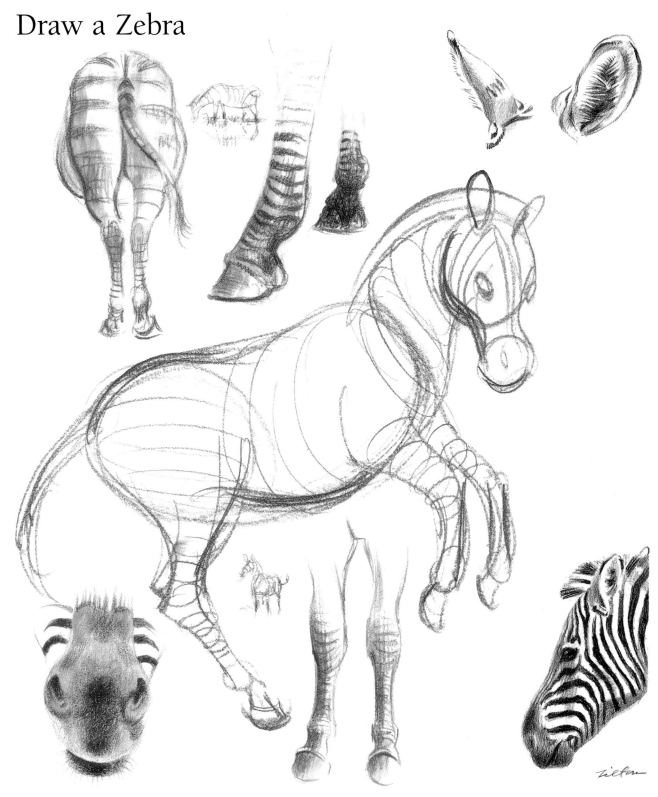

ZEBRA FOUNDATION

I began my zebra on tracing paper (pads of this paper are available at every art and craft store), successively refining the drawing and lightly applying fixative to it so I could trace my final drawing without smudging it. Working with 1-ply Bristol paper on a light table (which could be nothing more than a glass-covered box with sufficient lights under the glass to see through one or more sheets of paper placed on top), I carefully traced the last tracing paper drawing onto the sheet for my final drawing. This drawing is surrounded by detail drawings, developed a bit from my sketches from life at various zoos.

Refining the Zebra

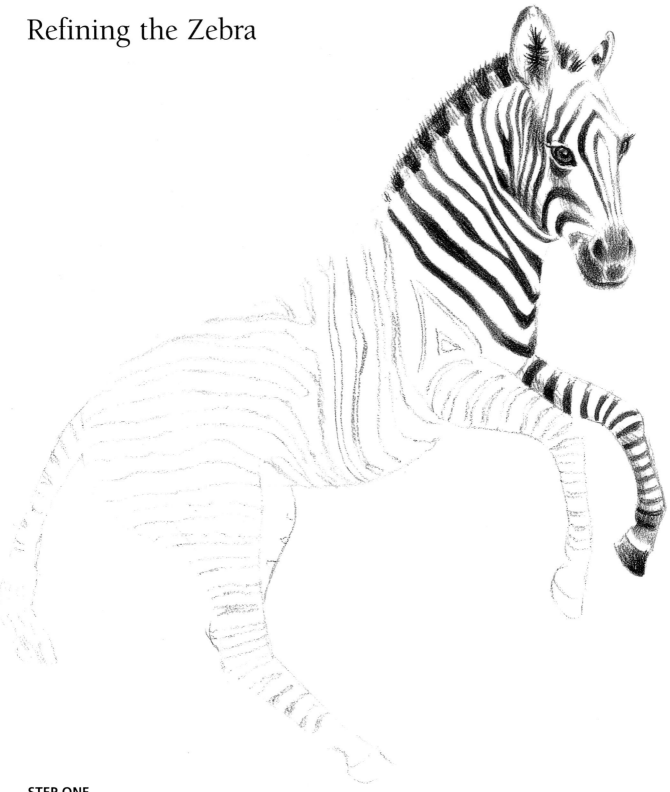

STEP ONE

To draw the zebra, simply ignore the stripes and stick with the fundamentals of the simple masses that identify this animal as a member of the equine family. You will find the peanut forms particularly useful for this project. Once the basic masses are drawn and linked together, carefully note how the stripes of various widths actually encircle and wrap around the form. These will help you make a more convincing drawing. Your basic masses can now be refined more precisely, and successful completion of your zebra is only a matter of patience and care.

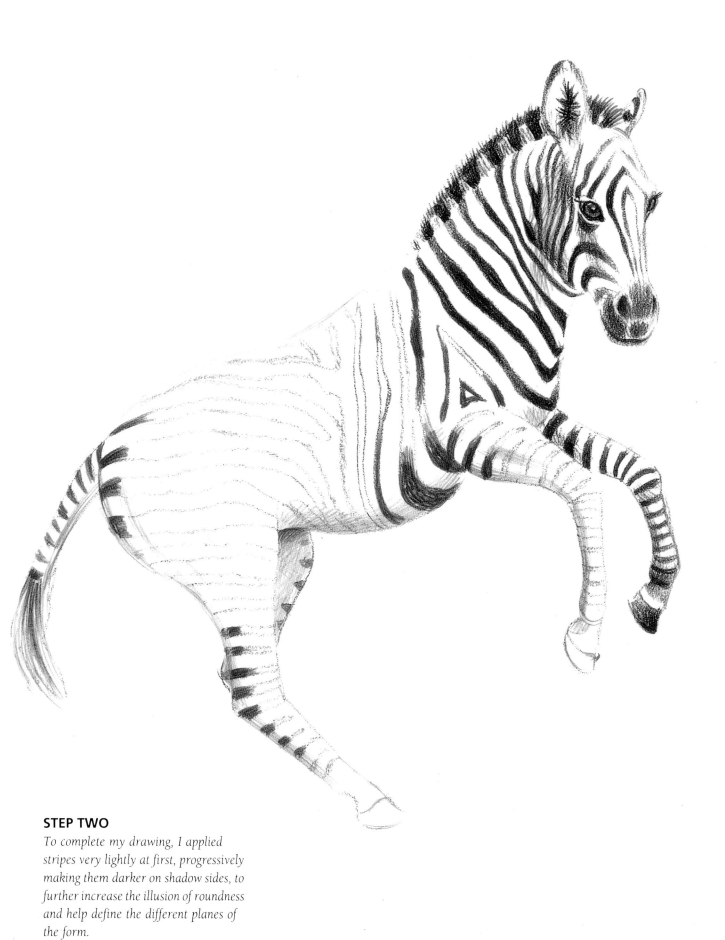

STEP TWO

To complete my drawing, I applied stripes very lightly at first, progressively making them darker on shadow sides, to further increase the illusion of roundness and help define the different planes of the form.

STEP THREE

As a last touch, I added grasses with very simple strokes that replicate the way grasses bend, twist and turn. These are loose, direct, unlabored strokes. Varying the thickness of your line and the pressure you apply, copy these grass strokes for practice and you will find it surprisingly easy. Drawing and painting leaves, bushes, trees, rocks, etc., requires nothing more than you have already learned: observation, sorting out the basic structures, putting the parts together, refining them, and with patience, finishing your project. That done, you are ready to tackle anything!

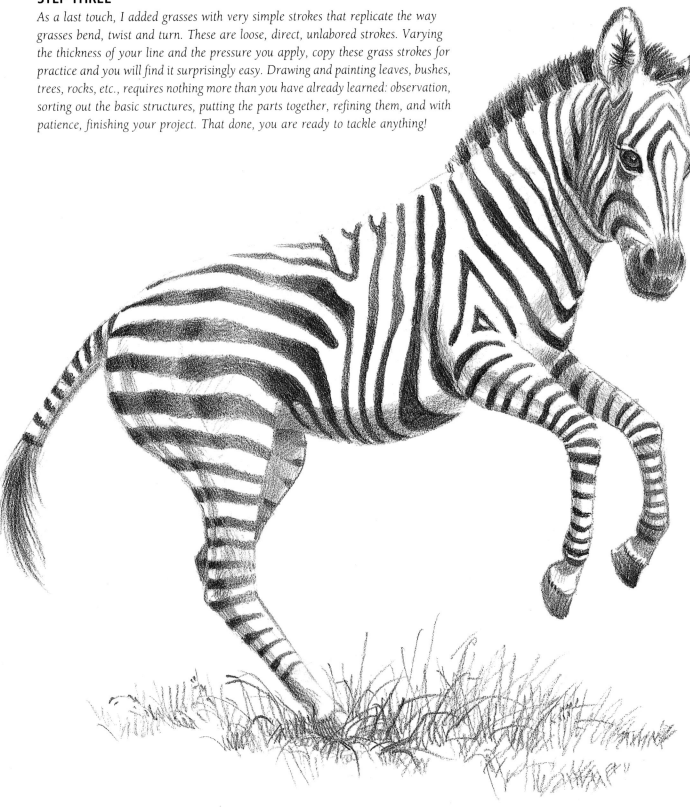

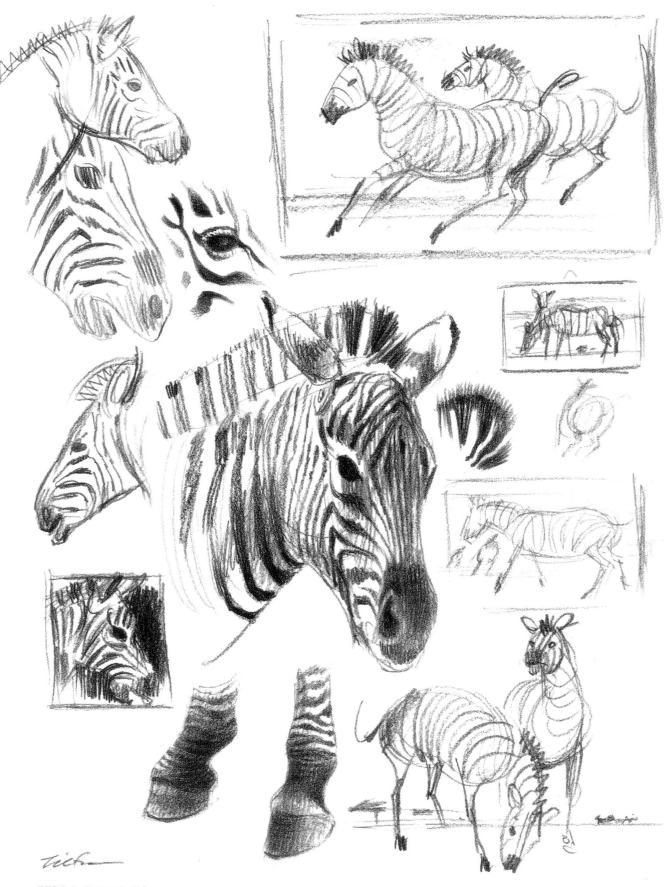

ZEBRA SKETCHES

Now that you have mastered my zebra drawing, why not practice what you have learned and try your own, original drawing? The possibilities are only limited by your patience and imagination.

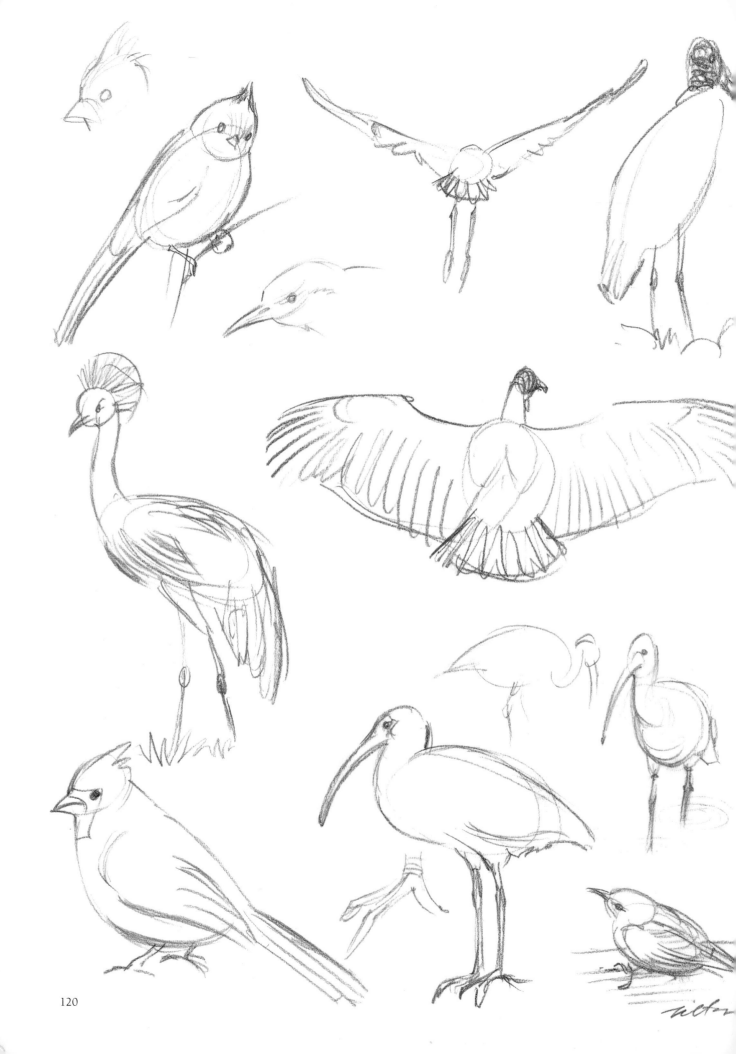

Epilogue

I n the introduction section I asked you to save your first drawing of the simplified bunny head. Now is the time to take it out of hiding and compare it and other examples of early work that you have done up to this point in time.

I hope you will be impressed with both your learning ability and your ability to teach yourself. My congratulations to you!

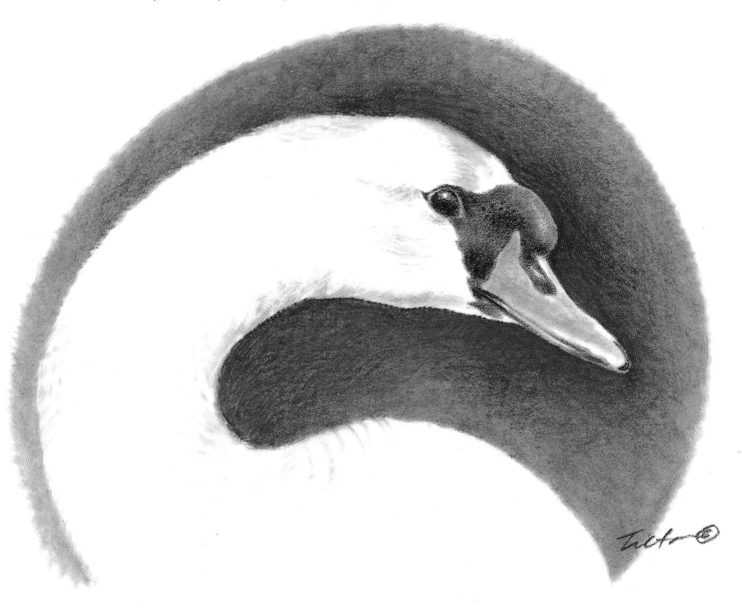

This final drawing is my "swan song."
Good luck with your own animal art!

Book, Magazine and Video Recommendation

Over the years, as I have been drawing and painting animals, I have tried to be aware of and collect beneficial, educational and instructional material related to animal art. Like many pack-rat artists, I enjoy an extensive library and good reference materials, but it is still a rare case when all the details are on hand when needed. Also, a lot of valuable material is out of print or simply unavailable. With that in mind, let me offer you a list of items of inestimable value to me as an artist as well as a never-ending pleasure to look at.

May I add that the illustrations in this book are based on my own photographs and on-the-spot sketches. On occasion I have turned to other reference material from a host of sources to augment, supplement or clarify some specific details I have emphasized for you. In no case have I used the wildlife or domestic art of others for details, no matter how splendid their work. But to restate the concept, this book is different, because I encourage you to copy my examples offered to you in lieu of hands-on instruction.

Books

Almost every animal-related book has something to offer, but were I limited to a few they would include:

1. *The Animal Art of Bob Kuhn* by Bob Kuhn, North Light Books. This is probably out of print, but it is worth searching for since Bob is hailed as an "artist's artist" among his contemporaries. Study this exceptional book and you will see how a brilliant master draftsman handles mass, gesture and uses his extensive knowledge.

2. *Drawing Animals* by Victor Ambrus, Chartwell Books. This large, beautifully illustrated and inexpensive book is a gem. Victor is an outstanding artist and the illustrator of over four hundred books, several of which he authored and several of which are important prize winners. Surprisingly, this book is often found in discount sections. His pencil and charcoal mastery are rightfully envied.

3. *Noah's Ark* by the late, great Rien Poortvliet of Holland, published by Abrams. The creator of *Gnomes*, I have collected this and all his follow-up books. Rien is another "artist's artist," earning lavish praise from many distinguished peers. Among his many fine books are *The Living Forest*, *The Farm Book* and *Dogs*, and his recent *Horses*. Each includes exceptional drawings and paintings of both animals and humans that reflect valuable, revealing, intimate, genuine knowledge.

4. *Wildlife Painting Step by Step* by Patrick Seslar, published by North Light, contains valuable instructional material. Perhaps somewhat advanced for those just starting out to draw and paint animals, it certainly belongs in your reference library.

5. I'd guess every serious animal artist has a copy of Dover Books' *An Atlas of Animal Anatomy* by W. Ellenberger, H. Dittrich and H. Baum. This big, soft-cover book is generously illustrated with more de-

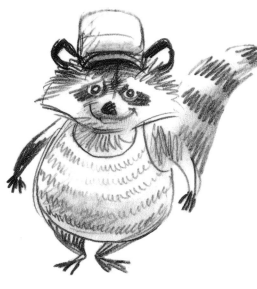

tail than you might ever have imagined and it is also inexpensive. Many well-stocked art stores carry it, but any bookstore can order this book, only one of Dover's many valuable art-related titles.

Other Books

The following books are a pleasure just to look at, read and enjoy. Most well-stocked bookstores have some of the wildlife art books I seek, but I have never found any one store that carries a complete range, nor for practical reasons do I expect them to.

That's why I recommend a dependable single source, the Wildlife Art Book Club, at (800) 626-0934. Books I especially like include:

Ray Harris-Ching: Masters of the Wild Series. Briarpatch Press.
Voice From the Wilderness. Ray Harris-Ching.
Wildlife: The Nature Paintings of Carl Brenders. Carl Brenders. Mill Pond Press/Abrams, 1994.
From the Wild. Christopher Hume, ed. NorthWord, 1987.
The Art of Bob Kuhn. Bob Kuhn. Briarpatch Press (out of print, well worth searching for).
The Animal Art of Wilhelm Kuhnert. Charles Wechsler, ed. Reprinted by Live Oak Press and Wildlife Art News, 1995.
Face to Face With Nature. The Art of John Seerey-Lester. William Eiland. Mill Pond Press, 1994.
Paintings From the Wild: The Art and Life of George McLean. David Lank.

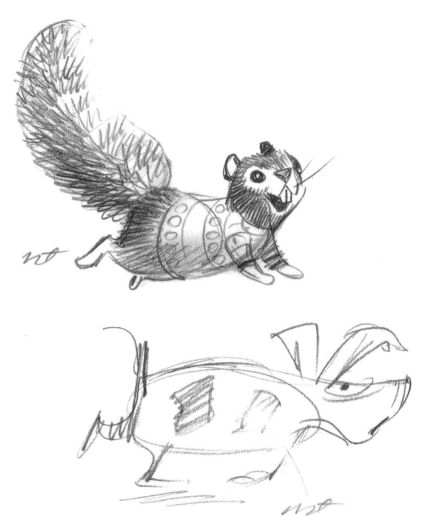

Magazines

In my opinion there is only one absolutely top-quality wildlife art magazine and that is Bob Koenke's *Wildlife Art*. Anyone that enjoys making and/or looking at fine wildlife art in many mediums and styles should subscribe to this one. This first-rate magazine is published by Pothole Publications, Inc., 4725 Highway 7, St. Louis Park, MN 55416. Contact Robert Koenke, Publisher, at (800) 221-6547.

Video

I think the best, most informative live-action videos related to wildlife come from the Discovery Channel, occasionally Public Service programs and National Geographic. The latter produces an exceptional video about zebras titled "Patterns in the Grass." I have purchased several of Marty

Stouffer's "Wild America" videos, finding all enjoyable and useful, despite some criticism of certain alleged staged events.

The most instructive, cost-worthy wildlife art instruction videos I have reviewed are the series featuring the fine oil and acrylic painting of John Seerey-Lester, working directly from life in various parts of the world. His "Creation" and "Painting Skies" are not part of his new wildlife series but they are both valuable. John's much sought-after teaching and workshop guidance is reflected in the lucid instruction of his videos. They seem almost hands-on. These videos represent a good investment because you can actually learn from them, unlike a host of other so-called instructional videos. Contact John Seerey-Lester, 240 Tamiami Trail, Venice, FL 34285.

Art Materials

Artists usually develop specific likes and dislikes related to the materials they work with, and I am no exception. For my "Drawing Board" column in *The Artist's Magazine*, workshops, demonstrations and, of course, commissions, I have positive, supportable feelings about what I work with. Moreover, I provide a Certificate of Authenticity and guarantee in writing my paintings will not fail (chip, peel, fade, etc.) during my lifetime, so I have confidence in my recommendations. With that in mind, here are various items you can count on for dependable performance, and may I add, I have no financial connection with any of them.

Paints

Having tested countless acrylics, I consider Golden Artist Colors produces the finest, most dependable product. Contact them at Bell Rd. New Berlin, NY 13411. Ask for their information kit and the source nearest you.

Gouache

Holbein's even, pure and dependable colors are unmatched and available at most art stores. Many fine wildlife artists use gouache since it permits such sharp detail and superb matte colors. I often seal the gouache-painted surface with retouch varnish, and when that's dry, overpaint with oil.

Watercolor

My favorite is liquid, specifically Hydrus, an outstanding watercolor made by Dr. Ph. Martin, and sold in most quality art stores. I am also impressed with M. Graham's new line of tube watercolors—smooth and flawless. When I work with pan colors, I turn to the boxed Russian product by Yarka, called St. Petersburg Artist's Colors. This company has made art products for some four hundred years, but naturally, our awareness of Russian art materials is only quite recent. Their high-quality, low-cost, 100 percent Siberian Kolinsky sable brushes are a real bargain. Many of the illustrations in my book are made with these brushes and these two paints. Fine buys for your money!

Oil

I work with four oil paints, and all are top quality. For utmost pleasure—the way the paint feels as it's applied—I use the very expensive and superb Old Holland Classic oil colors. Interchangeably, I use M. Graham & Co. Artist's Oil Color and Gamblin Artist's Oil Color. The latter two are made in Oregon by some learned young men and their product quality control is outstanding. Graham is an exponent of the Old Master's walnut oil and Gamblin is authoritative about solvents and varnishes. Graham and Gamblin produce outstanding painting mediums: Graham offers a Walnut Oil/Alkyd and Gamblin the Galkyd Painting Medium no. 1. I use both. In my opinion and experience the two manufacturers offer products of exceptional quality, and both are insatiable searchers for improved methods and

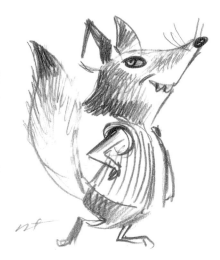

quality. Yarka also produces a fine, comparatively low-priced oil paint relatively new to our market, and I like it but my experience with it is not as broad as the others.

Colored Pencil

I often use colored pencil to add subtle shading and improve control when doing water-medium illustrations made for reproduction as well as certain gallery work. For such occasions, I normally turn to Faber-Castell Faber Design Watercolor pencils. These blend easily with a wet brush, mixing well with any water media I use, including damp pastel strokes. If your preference is the traditional, wax-based colored pencils, I recommend Faber-Castell's Design Spectracolor pencils. For smooth blending I use a small, round bristle brush dipped in mineral spirits, and I combine a sketch and wash pencil with the Spectracolors.

Pastel

There are too many excellent brands of pastel to list here. The best way to discover those best suited for your work is to seek the recommendations of pastel artists whose work you admire. I use a variety of pastels, from Othello pastel pencils to Nupastel square sticks to Sennelier, etc. For blending, all can be stroked together and rubbed together as well as

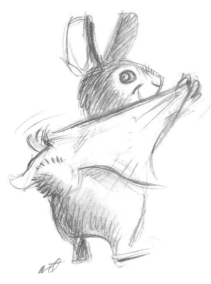

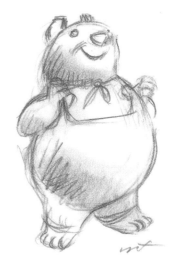

blended with water or mineral spirits for special effects. For oil pastels, refer to my lion head in color done with Sakura Cray Pas. An excellent product! Again, for blending I use different oil brushes and mineral spirits.

Pens

For highly detailed work requiring strokes of varied widths, I use the traditional croquill with its special holder and Gillott's no. 170 or Brause no. 66 extra fine points (look for mapping points) that fit regular pen staffs. When doing fine, detailed work, the typical contemporary pen is called a technical pen, some of which are refillable and others not. Their inflexible, round points vary in size, so personal selection is involved. For the last several years I have used Sakura's Pigma pens with real success. Their pen line has expanded considerably in color range and point

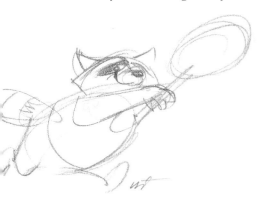

type. By all means try their Pigma Brush, a fine sketching tool, available in several colors.

Surfaces to Work On

Here are some drawing and painting surfaces I frequently work on and recommend as dependable, excellent-quality materials:

Strathmore Bristol drawing papers or boards from 1- to 5-ply are excellent for all mediums except, in my opinion, traditional, loose watercolor. The 4- and 5-ply bristol are excellent for gouache, many acrylic applications and for fine colored pencil work. Suitably primed, it's excellent for oil too. Almost any non-oily surface such as untempered Masonite (tempered, dark brown Masonite is oily and not recommended for any water-base mediums) will be satisfactory, particularly when coated with at least one application of acrylic gesso. The latter is sold throughout the country, is easy to apply and quick to dry. You can tint it with acrylic color to have a background color of your choice—try Acryla-Weave, a superior surface for acrylics, and, when properly primed, for oil too.

Canvas and Linen

Some excellent, prestretched products are on the market, but it's easy to learn how to stretch your own, saving money and often producing a superior product. Check your local art centers or art activities for guidance. Cheap canvas board is adequate for sketches and preliminaries only. If your work is serious and you want it to last, work only on reputable, quality materials. My preference is primed fine Belgian linen, but it is expensive.

Brushes

A lot of bewildering, plain awful brushes are on the market! Good brushes are so important, I recommend you turn to your local art store, most of which have an obvious pride and knowledge in what they sell. Those stores I buy from will always take time to demonstrate qualities of a good brush. I support and buy only from stores that will take the time to courteously help customers. When what I want isn't available locally, I turn to Pro/Art in Big Timber, Montana or Cheap Joe's Art Stuff in Boone, North Carolina. Pro/Art is owned by two exceptionally fine and renowned artists, Jessica Zemsky and Jack Hines, and they may be contacted at P.O. Box 1043, Big Timber, MT 59011. Cheap Joe is actually Joe Miller, and he may be contacted at (800) 227-2788. Joe is nationally known among watercolorists and despite his emporium's name, his business is really first-rate in every way.

Art Aids

Two art-related tools have served me well and I recommend them to you. For one, the "Tube Wringer" is a significant money saver, enabling one to get virtually all the paint from tubes. The other is called the "Artist's Handrest." The hand rest lets you apply paint, particularly detailed work, in a steadier manner, keeping your hand from pressing into wet paint. Your local art store should have or can get either item for you.

Index

More Books for Creating Great Art!

Painting Baby Animals with Peggy Harris—Now you can paint adorable baby animals with the help of professional oil painter Peggy Harris! You'll learn her fun, exciting and virtually foolproof method of painting using 11 color, step-by-step projects that show you how to paint a variety of realistic little critters—from puppies and kittens to ducklings and fawns. *#30824/$21.99/128 pages/319 color illus.*

How to Capture Movement in Your Paintings—Add energy and excitement to your paintings with this valuable guide to the techniques you can use to give your artwork a sense of motion. Using helpful, step-by-step exercises, you'll master techniques such as dynamic composition and directional brushwork to convey movement in human, animal and landscape subjects. *#30811/$27.99/144 pages/350+ color illus.*

The North Light Artist's Guide to Materials & Techniques—Shop smart with this authoritative guide to buying and using art materials in today's most popular mediums—from watercolor, oil and acrylic to charcoal, egg tempera and mixed media. You'll find personal recommendations and advice from some of North Light's most popular artists, as well as informed discussions on basic techniques, shopping lists, paints, surfaces, brushes and more! *#30813/$29.99/192 pages/230+ color illus.*

1997 Artist's & Graphic Designer's Market: Where & How to Sell Your Illustration, Fine Art, Graphic Design & Cartoons—Your library isn't complete without this thoroughly updated marketing tool for artists and graphic designers. The latest edition has 2,500 listings (and 600 are new!)—including such markets as greeting card companies, galleries, publishers and syndicates. You'll also find helpful advice on selling and showing your work from art and design professionals, plus listings of art reps, artists' organizations and much more! *#10459/$24.99/712 pages*

Wildlife Painting Step By Step—Capture the excitement and beauty of wild animals as you study demonstrations by distinguished wildlife artists. You'll cover every step of the painting process, from developing the idea to adding final details. Also included are specifics, such as capturing animal behavior, habitats, field sketching and more! *#30708/$28.99/144 pages/195 color, 30 b&w illus.*

The Art of Painting Animals on Rocks—Discover how a dash of paint can turn humble stones into charming "pet rocks." This hands-on easy-to-follow book offers a menagerie of fun—and potentially profitable—stone animal projects. Eleven examples, complete with material list, photos of the finished piece and patterns will help you create a forest of fawns, rabbits, foxes and other adorable critters. *#30606/$21.99/144 pages/250 color illus./paperback*

Zoltan Szabo's 70 Favorite Watercolor Techniques—Paint dramatic clouds, jagged rocks, rolling surf, the setting sun, rough tree bark and other popular nature subjects using Szabo's step-by-step techniques. *#30727/$28.99/144 pages/230 color, 6 b&w illus.*

Creating Textures in Pen & Ink With Watercolor—Learn how to use pen and ink and watercolors to suggest a wide range of textures from moss to metal to animal hair. You'll discover ways to use such diverse materials as technical pens, paint brushes, colored inks and liquid acrylics, and ways to alter and combine ink and watercolor for exciting texturing effects. *#30712/$27.99/144 pages*

Realistic Oil Painting Techniques—Discover how to create realistic, classically styled paintings that seem to glow from within. You'll find instructions on drawing methods for perspective and proportion, using halftones and highlights, seeing natural colors and recreating them, altering a painting's atmosphere and much more! *#30654/$27.99/144 pages/126 color illus.*

Painting Animals Step By Step—Learn how to paint dogs and cats, rabbits, cows, sheep, chickens and much more in watercolor and oil. In fifteen step-by-step demonstrations, you'll learn how to paint soft fur, create reflections in water and make even black and white animals colorful. *#30462/$27.95/144 pages/200+ color illus.*

Keys to Drawing—Proven drawing techniques even for those of you who doubt your ability to draw. Includes exercises, chapter reviews and expressive illustrations. *#30220/$21.99/224 pages/593 b&w illus./paperback*

Capturing Light in Oils—Learn how to create dramatic landscapes filled with a strong sense of place and time of day. In addition to clear instruction, 13 step-by-step demonstrations show Strisik in action—using light, color and design to paint expressive landscapes. Plus, you'll explore the visual effects of light and how to use them to create dramatic effects in paintings. *#30699/$27.99/144 pages/239 color illus.*

Drawing Nature—Discover how to capture the many faces and moods of nature in expressive sketches and drawings. In addition to learning specific pencil and charcoal techniques—such as circular shading, angular buildup, cross-hatching

and blending—you'll learn how to work with different materials and surfaces and how to render the most common elements of outdoor scenes. *#30656/$24.99/144 pages/237 b&w illus.*

How to Paint Trees, Flowers & Foliage—Learn how to paint believable trees, flowers and foliage and incorporate them into a picture as a whole. You'll find finished paintings in a variety of styles—plus step-by-step demonstrations in oils, acrylics, watercolors, gouache and pastels. *#30593/$27.99/144 pages/color throughout*

Paint the Changing Seasons in Pastel—Sixteen step-by-step painting demonstrations show you how to capture the majesty of every season—from early spring blooms to the first winter frost! *#30652/$28.99/144 pages/263 color illus.*

Painting Watercolor Florals That Glow—Capture the beauty of flowers in transparent watercolor. Kunz provides six complete step-by-step demonstrations and dozens of examples to help make your florals absolutely radiant. *#30512/$27.99/144 pages/210 color illus.*

Sketching Your Favorite Subjects in Pen & Ink—The first complete guide—for all types and levels of artists—on sketching from life in pen and ink. Written by Claudia Nice, a master of the subject, this book is presented in easy-to-follow step-by-step fashion. *#30473/$22.95/144 pages/175 b&w illus.*

Fill Your Watercolors With Light and Color—"Pour" life and light into your paintings! Here, Roland Roycraft gives you dozens of step-by-step demonstrations of the techniques of masking and pouring. *#30221/$28.99/144 pages/100 b&w, 250 color illus.*

Creating Textures in Watercolor—Discover how to paint 83 textures from grass to glass to tree bark to fur in this step-by-step guide including demonstrations. *#30358/$27.99/144 pages/115 color illus.*

Painting the Effects of Weather—How to paint sunshine, shadows, clouds, snow, ice, mist, wind, fog, rain, seasons and light—all the weather effects that give important expression to your work. *#30442/$27.99/144 pages/200+ color illus.*